P9-AGM-467

Word and Image

Word
and
Image

An Introduction to Early Medieval Art

William J. Diebold

ICON EDITIONS

Westview Press

A Member of the Perseus Books Group

*To my father and
to the memory of my mother*

All rights reserved. Printed in the United States of America. No part of this publication may be reproduced or transmitted in any form or by any means, electronic or mechanical, including photocopy, recording, or any information storage and retrieval system, without permission in writing from the publisher.

Copyright © 2000 by William J. Diebold

Published in 2000 in the United States of America by Westview Press, 5500 Central Avenue, Boulder, Colorado 80301–2877, and in the United Kingdom by Westview Press, 12 Hid's Copse Road, Cumnor Hill, Oxford OX2 9JJ

Find us on the World Wide Web at www.westviewpress.com

Library of Congress Cataloging-in-Publication Data

Diebold, William J.
 Word and image: an introduction to early medieval art / William J. Diebold.
 p. cm.
 Includes bibliographical references and index.
 ISBN 0-8133-3577-9
 1. Art, Medieval. 2. Christian art and symbolism—Medieval, 500–1500. I. Title.

N7850.D53 2000
709'.02—dc21
 00-025067

The paper used in this publication meets the requirements of the American National Standard for Permanence of Paper for Printed Library Materials Z39.48–1984.

Design by Heather Hutchison

10 9 8 7 6 5 4 3 2 1

Contents

Illustrations

Acknowledgments

❖⟦⟧⟦⟧❖

This book's genesis was an invitation from Lee Ripley Greenfield. Although that original project foundered, I am grateful to her for the invitation and even more grateful to Cass Canfield Jr. for following it up and believing my book worthy of the distinguished imprint he edits. I am also thankful to my students at Reed College, who responded critically to virtually all of the ideas in this book, generated some of them themselves, and tolerated their role as guinea pigs when I tested its organization and contents.

Thanks to all of the museums, libraries, and photo archives that provided photographs, especially those that reduced or waived their fees and therefore made this book possible. The Stillman Drake Fund of Reed College provided crucial support for the photographs and for a research assistant. That assistant, Anne Oravetz, was more talented and thorough than I could have hoped.

Kim Clausing, Abby McGehee Poust, and Isuru Senagama provided invaluable assistance at moments of crisis. Kathy Delfosse was an exemplary copy editor; she saved me from many errors and improved the text in all sorts of ways.

My family, Debby, Joseph, and Abby, not only gave me time to write this book, they often showed more enthusiasm for the process of writing it than did I. I first encountered many of the works of art I discuss in the company of my parents, Ruth and Bill Diebold. Without their love, support, encouragement, and example this book would never have come into being.

William J. Diebold

Sites Discussed in Text

Introduction

The Character of Early Medieval Art

n a letter written in the year 600, Pope Gregory the Great declared, "[W]hat writing offers to those who read, a picture offers to those who look; in it they read who do not know letters."¹ Gregory's text marks the chronological beginning of this book, an essay on the nature of visual art in Europe north of the Alps from 600 to 1050. More important, Gregory's letter also provides the book's conceptual foundation, the relationship between word and image in early medieval art. That theme is a telling entrée to my subject because, in the early Middle Ages, writing and pictures were inextricably linked. The understanding of the word/image relationship was continually shifting, and it will take the entire book to explore it in a nuanced way.

For now, I simply want to warn the reader that this book's very premise may seem strange; the modern tendency is to separate the verbal and the visual rather than to link them (many people today, for example, believe that the visual arts come from a hemisphere of the brain entirely distinct from that responsible for words and thoughts). In many ways I hope that this book's subject seems unfamiliar, for as much as early medieval art has resonated and continues to resonate with important currents in twentieth-century artistic production, much about it is odd, even bizarre, for the modern viewer; this is much of its appeal. The early medieval conception of art was strange, as were its forms. By the end of this book I will have given that

1

strangeness a context; to begin that process, I want to look closely at an exemplary image, a page from a manuscript of Gregory the Great's letters made in the German city of Trier in the 980s for Egbert, Trier's archbishop [Plate I].

This image, made almost four centuries after Gregory's death, attests to the pope's importance in the early Middle Ages. Because his letters were valued as statements of church doctrine and as models of epistolary style, they were collected into a *registrum*, a register; this painting served as a frontispiece to a copy of that text. It shows Gregory working on one of his influential Bible commentaries. As was typical for early medieval authors, the pope does not write the text himself but dictates to a secretary, who transcribes the words with a stylus onto a wooden tablet that has been hollowed out and filled with wax. The early Middle Ages had no other inexpensive writing material: Parchment or vellum, the treated skin of animals (on which this miniature was painted), was a difficult-to-prepare luxury; paper was unknown; and papyrus was almost impossible to obtain in northern Europe because the plant from which it was made grew only in Egypt. According to an early medieval biography of Gregory, one day the scribe, puzzled by Gregory's frequent breaks in dictation, used his stylus to pierce a hole in the curtain that separated him from the pope and saw the white dove of the Holy Spirit perched on Gregory's shoulder and speaking words of divine wisdom into his ear.

For my subject, the relation of word and image in early medieval art, this painting is almost too good to be true. A luxurious picture used to illustrate a book, it depicts the theologian whose association of images with words was central to the medieval understanding of art. This miniature indicates the crucial place of the word in the Middle Ages, for its subject is that word, both oral (the voices of the dove and of the dictating Gregory) and written (Gregory consults an open manuscript on the lectern in front of him while he holds another closed book in his right hand; the scribe writes on the wax tablet). But the picture also has as its theme vision, the sense without which art does not exist: The scribe, baffled by the absence of words from the pope's mouth, cannot solve the mystery with his ears, the organs of hearing; he is forced to pierce the curtain in order to use his eyes, the

organs of sight, which in this instance provide better evidence than his ears.

This miniature's subject, the relationship of word and image, is central to this book. But the painting is also an exemplar of early medieval style. Since I will have relatively little other occasion to treat that aspect of the art of the early Middle Ages, I want to consider it briefly here. The Western tradition of art, the tradition rooted in classical antiquity and its rebirth in the Renaissance, has made illusionism and verisimilitude central to the definition of art. Judged by the standard that a picture should look like what it represents, this late-tenth-century image of Gregory dictating is strange. There is, for example, the issue of scale. Even seated, Gregory is half again as tall as the scribe, who is standing. Or is he? From his posture he appears to stand, but his feet seem to float in the air. Indeed, the whole space of the image is difficult to read coherently. The screen of nicely classicizing Corinthian columns supporting the building within which Gregory works runs parallel to the plane of the picture. But how are we to understand the curtain through which the scribe pokes his stylus, hanging between two of the columns yet surely meant to be perpendicular to the picture plane?

This early medieval image is inexplicable when judged by the standards established by Italian Renaissance one-point perspective or the mechanical illusionism of photography. But those are not the proper standards to apply. The painter had concerns other than creating the illusion of reality. He represented Gregory much larger than the scribe because, from his perspective, Gregory was considerably more important. The Middle Ages was a rigidly hierarchical society; Gregory, as pope, saint, and distinguished author, was among its most elevated members, and the artist has used a whole series of devices to emphasize his importance. Gregory sits on a cushioned throne while the scribe stands. The pope occupies the center of an arch at the center of the image. And his head is marked by a large, ostentatious, and costly golden halo. Also working against illusion, and typical of early medieval art, is the interest in pattern and decoration. The miniature has a rigid geometrical structure: Columns running precisely perpendicular to the picture's top and bottom frames carry a golden archi-

trave finely bisected by a semicircle. Similar concerns are apparent in the scribe's clothing, which forms circular whorls on his stomach and falls into Vs on his legs.

The subject and spatial construction of this miniature are characteristic of the early Middle Ages. The image is typical in other ways as well. Although I identified its patron, Egbert of Trier, I did not name its artist, because he is anonymous to us. For convenience, modern scholars have made up a name for him, the Master of the *Registrum Gregorii*, after this, his most famous work. Our lack of knowledge of medieval artists' names is not simply an accident of the vast historical losses since the early Middle Ages. Rather, the early medieval conception of the artist, discussed in more detail in Chapter 5, did not esteem the individual creator nearly as highly as we do.

Also typically early medieval is this picture's function. We regard works of art as public, either because they were made for public display or because they are now part of public institutions such as the art market or museums. Although some early medieval art was public in this sense (notably the large-scale decoration of churches), most of the works discussed in this book had a much more restricted audience. This manuscript of Gregory's letters, for example, was made for the German emperor and would have been available only to a small circle around him. Furthermore, as a small object it could have been viewed by only one, or at most two or three people at the same time, a further guarantee of its private nature.

Unlike many historical or art-historical periods, there is no consensus about the chronological or geographical boundaries of the early Middle Ages. As a result, early medieval art has been conceived in very different ways. In this book I argue that this art is best understood by concentrating on the relationship of word and image, a relationship that was central in northern Europe and the Mediterranean from about 600 to about 1050. My claim is not that a single attitude toward word and image characterized the early Middle Ages in Western Europe but, rather, that an examination of the problem of word and image allows us to understand the diversity and complexity of early medieval art better than does any other organizing principle.

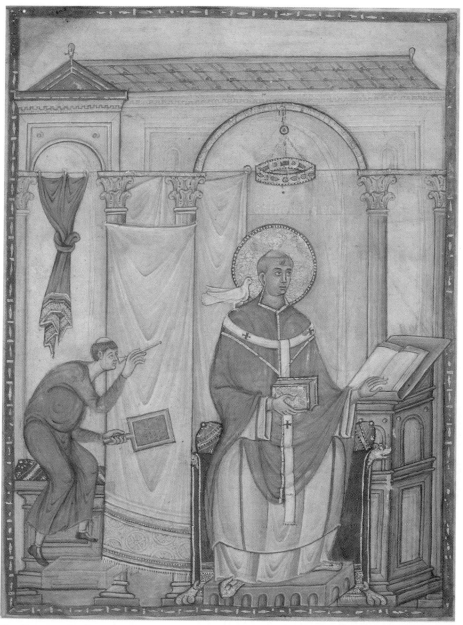

I Gregory the Great composing a text Registrum Gregorii. *Trier, probably
983–987. Trier, Stadtbibliothek, MS 171/1626. Photo: Stadtbibliothek.*

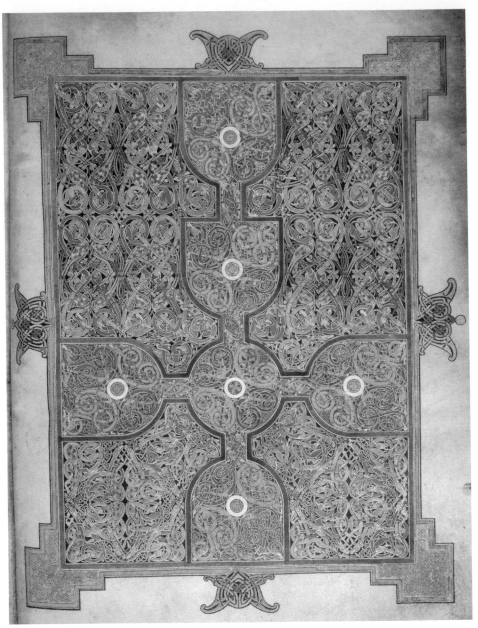

II. *Carpet page preceding the Gospel of Matthew. Lindisfarne Gospels. Lindisfarne,*
698–721. London, British Library, Cotton MS Nero D. iv, fol. 26v.
Photo: By permission of the British Library.

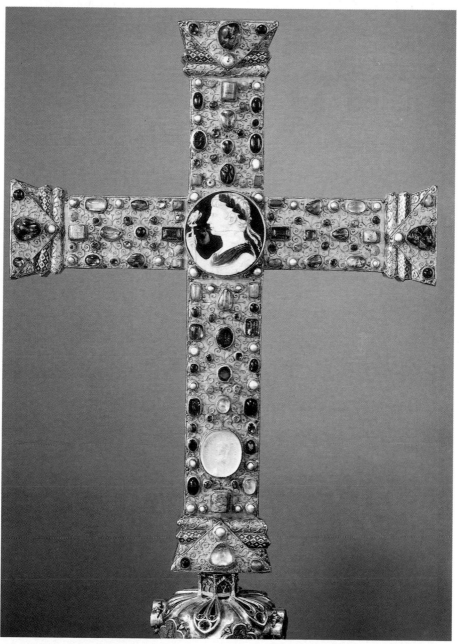

*111. Lothar Cross. Western Germany, c. 1000 (with Roman and Carolingian parts).
Aachen, Domschatzkammer. Photo: Domkapitel Aachen (Foto Münchow).*

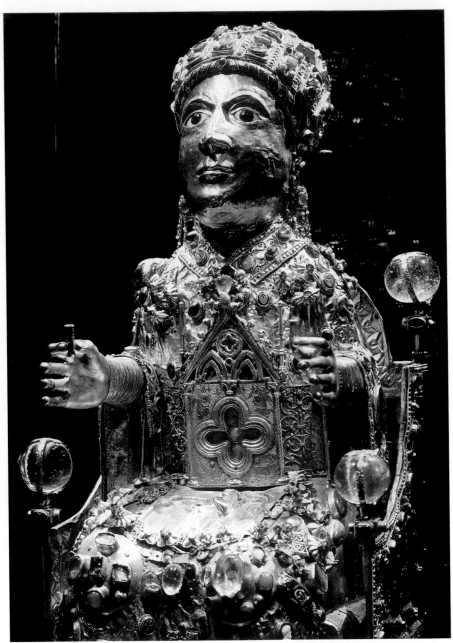

IV. Reliquary statue of St. Faith (front view). Conques, late ninth–first half of tenth century Conques Abbey, Treasury. Photo: Jean Feuillie © CNMHS.

How does this conceptual and chronological framework distinguish this book from other treatments of the period? Early medieval art is often understood as a series of revivals or rejections of classical antiquity. According to the revivalist conception, the fall of Rome engendered a thousand years of intellectual and aesthetic disaster, mitigated only by periodic renaissances of classical learning and art (notably at Charlemagne's court and in works such as the *Registrum Gregorii*). This view is problematic because it arbitrarily singles out classicizing works of art at the expense of others, just as characteristic and important, that do not look like the art made during Greco-Roman antiquity. Also prevalent is the diametrically opposed position, an equally essentialist strand of thought that ignores the classical aspects of the early Middle Ages to celebrate nonclassical, Germanic, or Celtic elements. The stigmatization of German nationalism after World War II has generally kept the Germanic variation of this argument out of favor in recent decades, but the Celtic version has recently recurred with a vengeance.[2] By contrast, the framework of this book requires that neither the classical nor the nonclassical aspects of early medieval culture be slighted. Another traditional conception of the early Middle Ages organizes the period around social players, particularly monks or kings. Although both groups figure large in this book, as patrons, makers, and users of much early medieval art, by eschewing them as an organizing principle I avoid such reductive historical formulas as "the early Middle Ages was an age of kings" (or, in other versions, "of monks"), which don't usefully distinguish the early from the later Middle Ages.

To be sure, my emphasis on word and image is not immune from criticism. Most notably, it has skewed the selection of works discussed somewhat in favor of illuminated manuscripts. Because these combine picture and text, they are especially powerfully engaged by examining the relationship of the visual to the verbal. But this is by no means a book about manuscripts. I have attended to the full range of early medieval artistic media, including architecture, because that full range can fruitfully be studied through the lens of word and image. My concern with the connection between the verbal and visual also means that I pay more attention to early medieval writing about art

than is customary in a work of art history. Because the early medieval conception of art was fundamentally different from our own, we cannot recover the meaning of that art simply with our eyes. These early medieval texts are themselves not transparent, but they are invaluable guides to interpreting the images.

If it is difficult to characterize the early Middle Ages, it is even harder to say when they began or ended. Historical periodization is a notoriously controversial subject, and rather than defending the chronological limits employed in this book, I will simply note how they relate to those established by others. Historians traditionally saw the early Middle Ages beginning either with the fall of Rome in the fifth century (the classic date here is 476, the deposition of the last Roman emperor in the West) or with Charlemagne's imperial coronation in 800. In recent decades, the invention of late antiquity has elided the sharp break between the classical and the medieval and has made both these dates seem ridiculous in their specificity.

Art historians, by contrast, typically see the early Middle Ages as beginning earlier, often with Constantine's conversion to Christianity in 312. Constantine's conversion made possible the production of Christian art on a large scale, and the Middle Ages is rightly seen as an era of Christian art. My decision to concentrate on the verbal and its relationship to the visual recognizes the importance of Christianity to early medieval art (for Christianity is preeminently the religion of the word), but I begin much later than Constantine, with Gregory's letter and his simultaneous decision to send a mission to the pagan Anglo-Saxons. By starting with Gregory, I signal his importance as a theorist of images in the Middle Ages and his central role in establishing the papacy as a political and social force, and I highlight the degree to which early medieval art results from the interaction between the culture of the Mediterranean and that of northern Europe, with its fundamentally different artistic forms, social structures, and languages. This interaction continued in various forms throughout the early Middle Ages, but an especially interesting, fruitful, and well-documented example is Gregory's mission to England.

The year 600 is also a useful starting date because it gives considerable breadth to our picture of early medieval Europe. By that date the barbarian invasions, the entry of non-Romans into the western part of

the Empire, had ended, but various regions had assimilated these migrations in different ways. In eastern France, the Low Countries, and western Germany, the Franks were settled and had been converted to Catholic Christianity for almost a century; in England, by contrast, the Anglo-Saxons were still pagan.

If the question of when the early Middle Ages began is contentious, the problem of when the period ended is messy. There is no consensus, but there is also little concern. Art historians traditionally stretch the period into the eleventh century, when another stylistic phase, the Romanesque, is seen to begin; or even into the twelfth and the beginning of the succeeding phase, the Gothic. For historians the terminus is equally unclear. My stopping point of 1050 follows art-historical tradition in perceiving the Romanesque as something different from the early Middle Ages. This difference manifests itself visually (Romanesque art looks different than early medieval art), but it stems ultimately from an altered conception of the image.

This book is meant as an introduction to early medieval art, both the images themselves and the methods used to study them. Its organization is roughly chronological. I begin with Gregory's mission to the Anglo-Saxons, which brought Christianity and literacy to a pagan, oral culture, and I contrast seventh-century England with the Continent. Chapter 2 presents the medieval Christian liturgy, the bringing of the Word to the people, for much early medieval art and architecture was liturgical. Chapter 3 examines more closely Gregory's claim that pictures were like books, showing how art created meaning in ways both like and unlike texts. This chapter argues that Gregory's theory of images was insufficient and provoked a crisis of word and image, a crisis documented in Chapter 4. Chapter 5 considers early medieval artists and patrons, drawing on evidence derived from inscriptions on the works of art themselves. The Conclusion studies an exemplary work of early medieval art, one both prospective and retrospective, the statue reliquary of St. Faith from Conques.

1

Books for the Illiterate?

⊷⊜⊷

Art in an Oral Culture

Christian legend holds that the religion had already reached northern Europe by the first century. Historical study indicates that the second or third century is a more likely date. And by the year 600, when the narrative of this book begins, Christianity was firmly established in some areas of Europe (Italy, southern France) but virtually unknown elsewhere (England, much of Germany). One of Gregory the Great's goals was to spread Christianity to those who were not Christian and to regulate Christian practice among those who were. Gregory is crucial to our story because images are one of the means he used to achieve these goals.

In 597 the pope sent a mission to England to convert the pagan Anglo-Saxons. This mission, led by Augustine (not to be confused with the more famous fourth-century bishop, author of *The Confessions* and *The City of God*), encountered the Anglo-Saxon ruler Ethelbert on the island of Thanet just off the southeast coast of England. The meeting of missionary and pagan king was described in an eighth-century British source, Bede's *History of the English Church and People:*

> After some days, the king came to the island and, sitting down in the open air, summoned Augustine and his companions to an audience. But

9

he took precautions that they should not approach him in a house; for he held an ancient superstition that, if they were practisers of magical arts, they might have opportunity to deceive and master him. But the monks were endowed with power from God, not from the devil, and approached the king carrying a silver cross as their standard and the likeness of our Lord and Saviour painted on a board.[1]

Two years after he sent the mission to England, Gregory wrote to Serenus, the bishop of Marseilles, on the Mediterranean coast of France. This region had long since been converted to Christianity, so Gregory's problem here was not outside the church but inside it. Serenus was an iconoclast, a breaker of images. The pope, Serenus's superior, reprimanded him for this practice:

> I note that some time ago it reached us that you, seeing certain people adoring images, broke the images and threw them from the churches. And certainly we praise you for your zeal lest something manufactured be adored, but we judge that you should not have destroyed those images. For a picture is displayed in churches on this account, in order that those who do not know letters may at least read by seeing on the walls what they are unable to read in books.[2]

Both of these texts indicate the important role Gregory assigned to pictures. Augustine's mission arrived with a likeness of Christ painted on a board (that is, an icon something like [1]). At Marseilles, Gregory condemned Serenus's destruction of images, even though in Serenus's estimation those images were being adored, a practice that Gregory agreed was unacceptable for Christians. By the end of the sixth century, then, images had become central to Christianity. Because Gregory's pro-image position became the standard Catholic one, we miss its strangeness. With our knowledge of the importance of art in the later Christian church (for example, Chartres Cathedral in the thirteenth century or the Sistine Chapel in the sixteenth, to cite only two very different cases), Gregory's endorsement of images seems natural. But in the early Middle Ages it was far from obvious that Christians would have images. Since virtually all of the art talked about in this book was made in the service of the church, it is

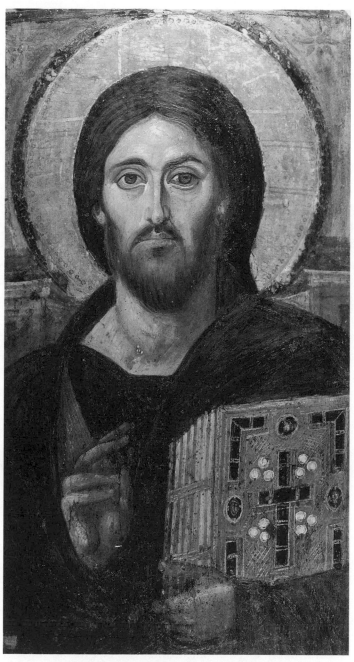

*1 Icon of Christ. Constantinople (?), sixth–seventh century.
Mt. Sinai, Monastery of St. Catherine. Reproduced through the
courtesy of the Michigan-Princeton-Alexandria Expedition to
Mt. Sinai*

important to understand how images achieved a central role in Christianity.

The question of the legitimacy of images arose for Christians because the two most important sources of Christian culture, classical antiquity and the Old Testament, both had their doubts about them. Plato's condemnation of images as nothing more than deceptive imitations of the truth was influential in the early church. And in the Old Testament, God himself had questioned the value of art, commanding, "Thou shalt not make to thyself a graven thing, nor the likeness of any thing that is in heaven above, or in the earth beneath, nor of those things that are in the waters under the earth. Thou shalt not adore them nor serve them" (Exod. 20:4–5).[3] Since the central Christian text, the New Testament, contains almost no reference to images, the Second Commandment was the most important statement on images for Christians. According to one strict reading, the commandment forbids representational art; thus, many Jews and Muslims prohibit images in synagogues and mosques. But from early on Christians tended to read the commandment more loosely, understanding the second part, "Thou shalt not adore them nor serve them," as governing the entire commandment. It was all right to make representational images as long as they were not worshiped. Art was fine, but idolatry was prohibited.

As Serenus's actions indicate, this looser interpretation of the Second Commandment did not please everyone. Unfortunately, we know almost nothing about what the practices were around images in Marseilles that drew Serenus's wrath. No statement by him survives, so we have only the evidence of Gregory's letter, which tells us that Serenus broke and threw from the church "images of holy persons." These may have been icons, painted or sculpted images of a single holy figure, such as the image of Christ that Augustine brought on the mission to England. None of the surviving Roman icons from this period happen to depict Christ, but a Christ icon from the eastern Mediterranean gives us an idea of what Augustine's painting looked like [1]. This panel (Bede's "board") was probably made in about Gregory's era, likely in Constantinople, the Byzantine imperial capital. It escaped the almost universal destruction of images that occurred in Byzantium during the iconoclasm of the eighth and ninth

centuries because it was (and is) preserved at the remote monastery on Mt. Sinai in Egypt.

Portraits of important people, such as the emperor or the revered dead, had been made in the pre-Christian Roman world. It was not altogether surprising, then, that Christians adopted the practice for images of their ruler, Christ, and their revered dead, the saints. The cosmopolitan audience in Marseilles would certainly have been familiar with images like the Sinai Christ icon and would have understood its pictorial language, for it was a language that had been current in the Mediterranean for more than a millennium. Marseilles, the oldest city in France, was founded by Greeks in about 600 B.C.; later, it had become fully Romanized and was a central city of the Empire. Paintings like the Christ icon are illusionistic: They are meant to resemble the things they depict. The purpose of pagan funerary portraits and Christian icons was to keep present those who were dead and gone. Illusionistic art depends on establishing a confusion between the representation, the painting or the sculpture, and the thing it represents. This confusion is the magic of this kind of art, but, construed less positively, it is also the root of idolatry. The iconoclast Serenus was probably defending against the idolatrous potential of such images by destroying them.

Another Gregory, also a bishop (this time of the central French city of Tours) and a contemporary of Serenus, provided direct evidence of sixth-century viewers mistaking an image for what it represents. He told the following story about an icon of Christ:

> After a Jew had often looked at an image of this sort that had been painted on a panel and attached to the wall of a church, he said: "Behold the seducer, who has humbled me and my people!" So, coming in at night, he stabbed the image with a dagger, pried it from the wall, concealed it under his clothes, carried it home, and prepared to burn it in a fire. But a marvelous event took place that without doubt was a result of the power of God. For blood flowed from the wound where the image had been stabbed. This wicked assassin was so obsessed with rage that he did not notice the blood. But after he had made his way through the darkness of a cloudy night to his house, he brought a light and realized that he was completely covered with blood. At dawn the Christians

came to the house of God. When they did not find the icon, they were upset and asked what had happened. Then they noticed the trail of blood. They followed it and came to the house of the Jew. They searched carefully for the panel and found it in a corner of a small room belonging to the Jew. They restored the panel to the church; they crushed the thief beneath stones.[4]

This distasteful tale is both anti-Semitic and unbelievable. But it is also telling. The Christian bishop Gregory of Tours takes the existence of images for granted. He knows that because of their reading of the Second Commandment, Jews did not have such images, and he imagines that they would find them fascinating. Most important, Gregory's story assumes a perfect identity between the image of Christ and Christ himself. The painting bleeds when stabbed, just as Christ would. The real Christ, of course, had long since ascended to heaven, so the image is the only available surrogate; thankfully, it is a perfect one.

Gregory the Great was surely no proponent of idolatry. But he saw the value of illusionistic images for providing a focus for Christian faith, especially if they were regarded as stand-ins for the absent Christian god and saints—hence his condemnation of Serenus's iconoclasm and his decision to equip Augustine with pictures for his mission to England. But an image that functions one way in one context can operate very differently in a different context. I have considered how the Christ icon would have been received in Mediterranean Marseilles in the year 600; what about in far-away Thanet? Britain had been the last part of western Europe to be added to the Roman Empire and was the first to be lost. By the time of Augustine's mission, such elements of the Roman heritage as the Latin language or illusionistic images had been long forgotten or actively suppressed by the invading Saxons. The visual culture in Britain was very different from that of Rome or Marseilles.

Around 625 a powerful Anglo-Saxon noble, perhaps a ruler, was interred in eastern England in a ship placed in a huge burial mound. Excavated in 1939, mound 1 at Sutton Hoo, as the place is now known, is one of the most remarkable archaeological finds of the twentieth century [2, 3]. The Sutton Hoo grave goods, of exceptional

2 *Shoulder clasp from Sutton Hoo. Southern England, c. 625. London, British Museum. Photo: The British Museum*

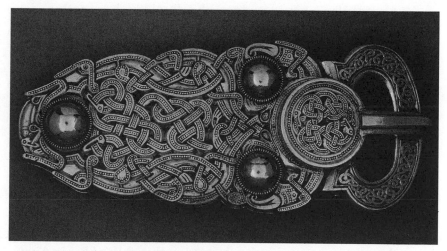

3 *Belt buckle from Sutton Hoo. Southern England, c. 625. London, British Museum. Photo: The British Museum*

richness and technical virtuosity, are almost precisely contemporary with the Christian mission to England, but they show almost no sign of having been touched by that mission, even though Sutton Hoo is not far from Thanet. They are artifacts of the pagan, oral culture of the Anglo-Saxons, a culture forever changed after contact with the literate Mediterranean Christians. Mediterranean culture was not completely unknown to the ruler interred at Sutton Hoo; buried with him were a silver plate stamped with Byzantine imperial control marks and a selection of gold coins from Gaul.

But the Sutton Hoo burial is striking for the absence of Christian artifacts. Instead, we find such accoutrements of a warrior king as a helmet and scepter and spectacular pieces of jewelry, including a shoulder clasp for a cloak and a belt buckle. The primary decoration of the shoulder clasps is made of thin slices of garnet laid over gold foil scored with patterns to reflect the light. A special checkerboard glass of black and blue contrasts with the predominating gold and red. The aesthetic of pattern and decoration governs both the figurative scenes (the grazing boars on the shoulder clasps and the animal-headed interlace on the belt buckle) and such purely ornamental areas as the rectangular central panels on the shoulder clasps and the loop of the belt buckle. Although the pieces from Sutton Hoo are lavish, they are also small; the art of the Anglo-Saxons was portable and secular. This was the visual world that Augustine's missionaries entered.

We do not have the "likeness of our Lord and Saviour painted on a board" brought by the missionaries. Bede also wrote, however, that Gregory equipped Augustine with "many books," and by remarkable chance, it appears as if one of these has survived. Medieval tradition connected a gospel book, then preserved in the English city of Canterbury, with Augustine, who founded the church there [4, 9]. Since the manuscript was made in Italy late in the sixth century, there is every reason to think it is one of the books Gregory sent with Augustine. Even if it is not, the Gospels of St. Augustine (as the manuscript is now known) must be very close indeed to the kinds of books Augustine had with him on the mission. Each of the four gospels was preceded by a portrait of the evangelist, the gospel's author. Only one of these remains; it depicts Luke, seated in a contemplative pose with his gospel open on his lap [4]. In the arch above Luke is an ox, the symbol

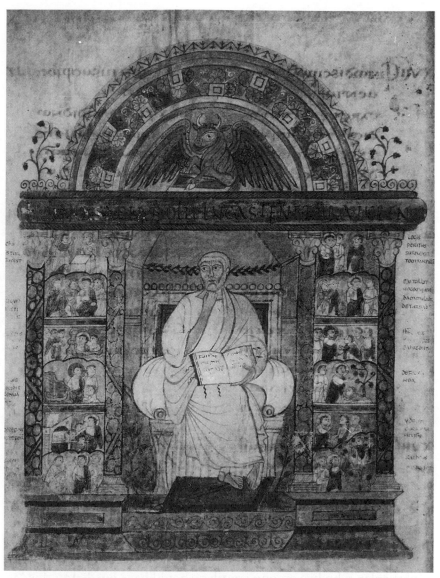

4 *Luke. Gospels of St. Augustine. Italy, probably Rome, late sixth century. Cambridge, Corpus Christi College, MS 286, fol. 129v. Photo: The Master and Fellows of Corpus Christi College, Cambridge*

associated with him. To the left and right are small scenes from the life of Christ, the story told in the gospel.

Parts of England had been converted to Christianity in late antiquity, but the Saxon conquest of England in the fifth century completely suppressed the religion in Britain. It also suppressed literacy, for the Saxons, like all of the invading barbarians, had no written language. Theirs was an oral culture. With Augustine's mission, reading and writing were brought back to the British Isles. This should not be construed as contact between a high, literate Mediterranean culture and a low, illiterate Saxon one. Literacy and superior culture do not necessarily go hand in hand. But there is a crucial link between Christianity and literacy, for Christianity, in contrast to either Roman or Germanic pagan religion, is a religion of the book; it possesses a written record of divine revelation. The importance to Christians of the word is clear in the first sentence of the Gospel of John: "In the beginning was the Word, and the Word was with God, and the Word was God." A little later, John describes Christ's incarnation, his arrival on earth, as "the Word made flesh" (John 1:1, 14). John wrote in Greek and used the rather abstract Greek word *logos* ("thought, mind"), which Jerome's Vulgate literally rendered into Latin as *verbum*, "word." This translation gave the concrete word a special place in Latin Christianity.

The Gospels of St. Augustine are one expression of that word. But the manuscript also contains images. What is their function? In his letter to Serenus, Gregory wrote that pictures substitute for the sacred word, allowing the illiterate to read what they cannot read in books. The pope thought images were especially important as a tool for conversion; he equipped the missionaries to England with paintings and condemned Serenus's iconoclasm because "especially for gentiles [non-Christians] a picture stands in the place of reading. You in particular, who live among gentiles, should have heeded to this."[5]

Gregory seems not to have distinguished between the role art played in Serenus's mission and in Augustine's. But we must, if we are to understand his idea that pictures are the books of the illiterate, for that metaphor would have meant two very different things in the Mediterranean and in England. In late-sixth-century Marseilles books were rare and expensive, so only a very few Christians would

have had physical access to written texts. But Latin, the language of the Bible, was also the spoken vernacular, so most of what went on in church (sermons, readings from scripture) would have been perfectly comprehensible to the congregation, with or without the aid of pictures. Mediterranean gentiles, too, would have known the relevant languages: the written and spoken Latin and, just as important, the pictorial language of Mediterranean art. They would not, however, have been familiar with the Christian stories, so Gregory is probably imagining that for them pictures would replace or supplement narrative texts. In England the situation was very different. The Anglo-Saxons neither wrote Latin nor spoke it, so the words of the missionaries required translation into the vernacular. Pictures could thus have played a crucial part in the transmission of ideas because they are already in a kind of vernacular, accessible to all.

Or are they? The miniatures in the St. Augustine Gospels are a cruder version of the exquisite Mediterranean style of the Christ icon from Mt. Sinai, but they retain traces of its illusionism. The art of the Anglo-Saxons, by contrast, was very different. Much of it, like the rectangular portion of the shoulder clasp from Sutton Hoo [2], was nonfigurative. When figures are represented, as in the rounded section of the clasp, they are extremely stylized. Anglo-Saxon art has an almost heraldic concern for symmetry; the grazing boars on the shoulder clasp, for example, interlock so precisely and so fully that they are difficult to read for eyes not schooled in this pictorial tradition. The belt buckle, too, has an axis of symmetry [3].

This interest in pattern is very different from Mediterranean art, which values difference and individual detail [4]. Although the scenes flanking Luke in the St. Augustine Gospels are as simple as can be, they retain enough individual detail and incident to allow us to distinguish one from the other. This is a basic requirement of narrative art. The images Augustine brought on the mission would thus have appeared strange to the Anglo-Saxons. The media of these images, painted panels and illuminated manuscripts, were unfamiliar; the illiterate Anglo-Saxons had no tradition either of books or of painting. And their forms, rooted in classical illusionism, would have been odd, perhaps even incomprehensible; anthropologists, psychologists, and art historians are still debating whether the illusionistic representa-

tional schemes used in the Mediterranean are naturally comprehensible or if the ability to read them is culturally determined.

However the Anglo-Saxons understood the missionaries' images, it was surely not as books for the illiterate, a metaphor without meaning to a people without books. But the very strangeness of these pictures may have been perceived by Gregory as a missionary advantage; a century and a half later another missionary, Boniface, trying to convert the pagans in Germany, requested a manuscript of part of the New Testament written in gold "to impress honor and reverence for the Sacred Scriptures visibly upon the carnally minded to whom I preach."[6] Boniface did not care whether the pagans could read the Bible as long as they were impressed by its appearance. Although Gregory may not have shared Boniface's thinking, it is in books that the most remarkable interactions between pagan Anglo-Saxon and Christian Mediterranean culture are found.

Given that the Anglo-Saxons had no indigenous tradition of making manuscripts, it is all the more surprising that among the greatest glories of early medieval art are a series of gospel books made in the British Isles in the two centuries after the arrival of the missionaries. The Book of Durrow [5–8] is probably the earliest of these insular gospel books (so called because all were made on an island, either the British Isles or Ireland). The evidence for dating Durrow is slim, but it was probably produced in the second half of the seventh century. Even more vexed is the question of its place of origin. The book takes its name from the Irish monastery of Durrow, where it was preserved in the Middle Ages. But it seems probable that the manuscript was actually made at a monastery elsewhere, most likely in Northumbria, in the extreme northeast corner of present-day England. The long-standing differences between the English and Irish have made this question of where the great insular gospel books were written and illuminated seem of great importance. But that question would have made little sense in the seventh century. Because the entire north of England had been converted to Christianity by Irish monks, Northumbria and Ireland were a unified cultural landscape. (This would change later when the Christianity brought by the Roman missionaries came into conflict with the Christianity of the Irish monks.)

5
*Lion of John.
Book of Durrow.
Probably northern
England, second half of
the seventh century.
Dublin, Trinity College,
MS 57, fol. 191v. Photo:
The Board of Trinity
College, Dublin*

As a gospel book written in Latin, the Book of Durrow is an artifact of Mediterranean Christianity, but its decoration has little to do with the Mediterranean. Like most insular gospel books, Durrow has three different kinds of ornamentation: carpet pages, symbols of the evangelists, and decorated letters. The evangelist symbols are closest to the Mediterranean tradition. In Durrow each gospel is prefaced not by a portrait of the evangelist, such as the image of Luke in the St. Augustine Gospels, but by a depiction of the evangelist's symbol. The biblical

6
Man of Matthew.
Book of Durrow.
Probably northern
England, second half of
the seventh century.
Dublin, Trinity College,
MS 57, fol. 21v.
Photo: The Board of
Trinity College, Dublin

books of Ezekiel and Revelation describe a vision of God's throne sur-
rounded by four creatures: man, lion, ox, and eagle. In the Middle Ages
each was understood to refer to one of the evangelists. According to the
usual system of correspondence, devised in the fourth century by
Jerome (but not in fact used in Durrow), the man symbolized Matthew,
the lion Mark, the ox Luke, and the eagle John. In Durrow the lion is
used as the frontispiece to the Gospel of John [5]. Whereas in the St.
Augustine Gospels the artist had depicted the evangelist and his symbol
[4], in Durrow only the animal symbol is shown.

This is the insular challenge to the anthropocentric art of the Mediterranean; although the Book of Durrow's text tells the story of a Mediterranean god in human form, the manuscript was made in a different world, one lacking the Mediterranean pictorial tradition's emphasis on human action. Thus, human figures are largely absent.7 The Durrow lion deviates from Mediterranean tradition in other ways as well. The page is surrounded not with an architectural frame giving the illusion of depth, as in the St. Augustine Gospels, but with a border of nonfigurative interlace. Nor was the Durrow artist interested in illusionism or foreshortening. The lion is shown in strict profile; color is abundant, but it forms abstract patterns rather than defining muscles.

Seen from the Mediterranean perspective of Augustine's mission or his gospel book, this symbol page of the Book of Durrow would have seemed strange. Other pages in the manuscript are even odder. As is common in insular gospel books, each gospel was originally preceded by a full page of abstract ornament [7]. The modern name for these, carpet pages, is anachronistic and unsatisfactory; unfortunately, we have no notion of their early medieval name or, more important, of their function. Although the carpet pages in later insular gospel books are frequently designed around the Christian symbol of the cross [Plate II], this is generally not the case in Durrow. From the example of objects like those found at Sutton Hoo, we know that the ornament on the Durrow carpet pages (in this case interlace, on other pages spirals and entwined beasts) was part of the pre-Christian decorative vocabulary of both the Anglo-Saxon and Celtic inhabitants of the British Isles. Precisely because these people were not literate, however, we have no written records of what such patterns might mean.

The basic art-historical method by which meaning is given to works of art is called iconography, a name coming from the Greek words for image and writing. Iconography brings texts into conjunction with pictures. In the case of works of art from past oral cultures, such texts are unavailable and iconographic analysis flounders. By the time the Book of Durrow was made, of course, literacy had reached the British Isles; it is, after all, a book. But no Christian writer of the Middle Ages ever discussed the significance of interlace or the other patterns. In the late twelfth century the priest Gerald of Wales, describing an earlier insular gospel book that must have looked something like the Book of Durrow, wrote:

Look more keenly at it, and you will penetrate to the very shrine of art.
You will make out intricacies, so delicate and subtle, so exact and com-
pact, so full of knots and links, with colours so fresh and vivid, that you
might say that all this was the work of an angel, and not of a man.[8]

Five centuries after the Book of Durrow was made, Gerald was as-
tounded by the interlace, but he refused to give it a meaning; I sus-
pect he, too, was unsure what to make of it.

Whatever the precise function of carpet pages in insular gospel
books, whatever their relationship to the pre-mission art of the
British Isles, it is important to recognize that they are not pagan or
anti-Christian. If they were, they would never have been included in
the most sacred of Christian texts. They were probably put in these
manuscripts to help make the strange written text that is so central to
the Christian religion more familiar to the only recently Christian-
ized people of Britain. Gregory the Great believed that just such a
strategy of conciliation with the pagans was useful for successful mis-
sion work. In 601 Gregory sent a message for Augustine:

Inform him that we have been giving careful thought to the affairs of
the English, and have come to the conclusion that the temples of the
idols among that people should on no account be destroyed. The idols
are to be destroyed, but the temples themselves are to be aspersed with
holy water, altars set up in them, and relics deposited there. In this way
we hope that the people, seeing that their temples are not destroyed,
may abandon their error and, flocking more readily to their accustomed
resorts, may come to know and adore the true God. And since they have
a custom of sacrificing many oxen to demons, let some other solemnity
be substituted in its place, such as a day of Dedication or the Festivals of
the holy martyrs whose relics are enshrined there. For it is certainly im-
possible to eradicate all errors from obstinate minds at one stroke, and
whoever wishes to climb a mountain top climbs gradually step by step,
and not in one leap.[9]

The makers of the insular gospel books included traditional Anglo-
Saxon forms in an attempt to put Gregory's doctrine into practice.
Were they successful? This is a difficult question, for we have little firm

evidence of the intended audience for these books. They could have been used by the monks who made them in the Christian liturgy (discussed in more detail in Chapter 2), but Boniface's letter indicates that luxury manuscripts such as the Book of Durrow were used to convert pagans as well as to serve those who were already Christian. But it is too simple to say that these insular books were richly decorated only in order to awe the pagans. More is at stake than that. Until the arrival of the Roman missionaries, the Anglo-Saxons had never encountered writing. Because literacy is such a powerful tool for structuring thought, we, who live in a fully literate society, cannot simply imagine what the Anglo-Saxons' first encounter with reading and writing was like. But similar situations have been studied in our era by anthropologists. Particularly useful is Jack Goody's work on the arrival of Islam in sub-Saharan Africa. There, as in England around 600, the word came to the illiterate in the form of a sacred text. The result was that writing took on a special meaning; its "major function was communication to or about God [and] it was the magical-religious aspect which most impressed the majority of the population."[10] This was precisely what happened in seventh-century England as well.

The Gospel of Mark in the Book of Durrow begins with the Latin phrase *"Initium evangelii Ih[es]u Xr[ist]i"* [the beginning of the gospel of Jesus Christ], words that fill the page's first three lines [8]. Our difficulty in reading these words does not lie in the distance that separates us from the Book of Durrow; we have little problem deciphering the same text from the even older Gospels of St. Augustine [9]. Durrow is hard to read because the scribe/artist manipulated the scale and form of the letters and broke them up with ornament and color. If we know what the text says, with a little study we can see that he has bound the initial *i* and *n* of *initium* together, used interlace in the uprights of the letters, turned the downward stroke of the *n* into a fantasy of spirals, and placed the first four words of the gospel on rectangular fields of tiny red dots. Clearly he was not aiming at legibility. The same text from the Book of Kells [10], a somewhat later gospel book, shows the astounding degree to which insular artists were willing to alter the standard letter forms.

In the Mediterranean tradition, by contrast, letters were never disrupted. The page with the corresponding text from the Gospels of St.

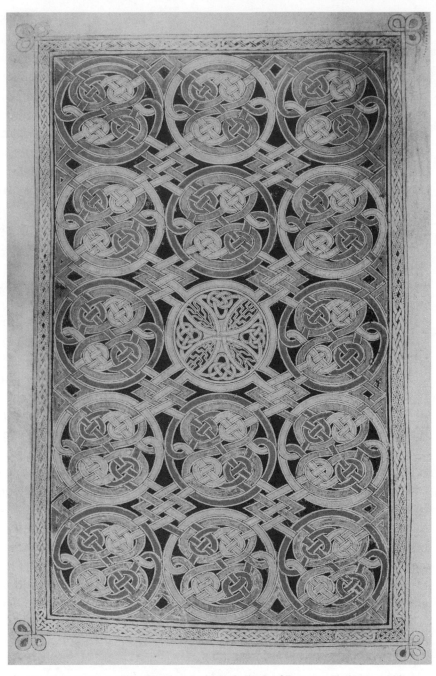

7 *Carpet page preceding the Gospel of Mark. Book of Durrow. Probably northern England, second half of the seventh century. Dublin, Trinity College, MS 57, fol. 85v. Photo: The Board of Trinity College, Dublin*

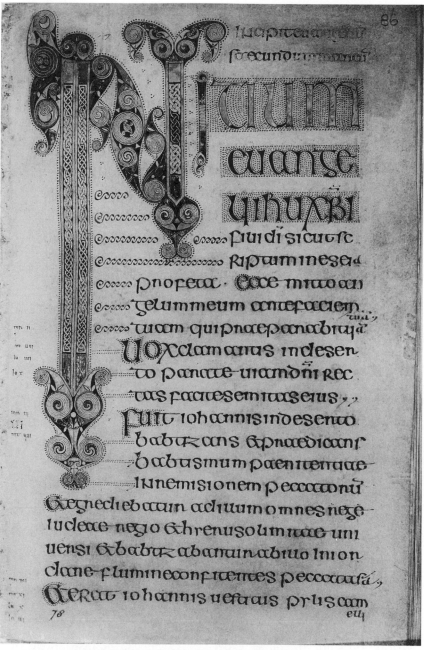

8 *Beginning of the Gospel of Mark. Book of Durrow. Probably northern England,
second half of the seventh century. Dublin, Trinity College, MS 57, fol. 86.
Photo: The Board of Trinity College, Dublin*

Augustine is sober [9]. A few letters are increased in size and moved into the margins to mark important text divisions, but the standard forms of the letters, the key to legibility, are consistently maintained. The legibility of the St. Augustine Gospels is what we expect in a book. The literate Mediterranean world used writing in a variety of spheres: religion, law, business, literature. In such a culture (like ours), where literacy is routine, words are used for all sorts of communication and need to be immediately recognizable. In England, however, writing was anything but routine; its use was restricted to religious texts written in a foreign language. In this context the word took on a magical aspect. What mattered was not its legibility or what it said, but simply its existence.

As a result, the insular books were magic. Bede reported that he had "seen that folk suffering from snake-bite have drunk water in which scrapings from the leaves of books from Ireland have been steeped, and that this remedy checked the spreading poison and reduced the swelling."[11] One of the earliest Irish books, a Psalter, is known as the Cathach ("Battler") because it was carried into battle to help wage war. Uniquely insular are book shrines, elaborate boxes of metal and jewels made to hold the gospels. The shrine of the Book of Durrow is lost, but another eighth-century box for a gospel book survives: the Soiscel Molaise ("the satchel of St. Molaise") [11]. Many of these boxes were sealed, making access to the book impossible; rather than simply protecting the magical book they enshrined it. Again, it is the power of the writing rather than its legibility that was important. Perhaps the most remarkable testimony to the magic force of these books is that as late as the seventeenth century an Irish farmer attempted to cure his cattle—stricken with hoof-and-mouth disease—by plunging the Book of Durrow into their water trough!

Goody, studying the impact of Islam and writing on the oral culture of northern Ghana, encountered precisely parallel phenomena.[12] Compare this account by the twentieth-century anthropologist to Bede's eighth-century report:

Writing does not, of course, expel magic. Indeed, the instruments of writing easily become invested with supernatural powers, particularly where writing is primarily a religious activity. Especially is this true of the ink and other colouring used in writing on paper, papyrus, slate or

9 *Beginning of the Gospel of Mark. Gospels of St. Augustine. Italy, probably Rome, late sixth century; the drawing is later, English, tenth–eleventh century. Cambridge, Corpus Christi College, MS 286, fol. 78. Photo: The Master and Fellows of Corpus Christi College, Cambridge*

skins, for the material that actually gives concrete embodiment to speech is held to encapsulate the communicative power of the word. To wash the colour from off the writing surface and then swallow it down is to drink in, to internalize, a power which would otherwise remain external to the imbiber.

The gap between the conceptual framework and the terminology of the two writers is vast, but they describe the same practices. In Ghana

10 *Beginning of the Gospel of Mark. Book of Kells. England or Ireland, probably eighth century. Dublin, Trinity College, MS 58, fol. 130. Photo: The Board of Trinity College, Dublin*

*11 Soiscel Molaise book shrine. Ireland, eighth century; expanded in
eleventh and fifteenth century. Dublin, National Museum of Ireland.
Photo: National Museum of Ireland*

Goody himself had been offered "the blackened water," water into
which paper with the Koran written on it in ink had been dipped; and
he catalogued similar practices of "drinking the word" throughout
West Africa, as well as in Egypt, Madagascar, Tibet, and China
(Bede's evidence escaped his attention).

The dichotomies I've presented as characteristic of the Roman mis-
sion to England (oral/literate; Latin/vernacular; pagan/Christian) will
recur throughout this book, for they are crucial to the historical de-

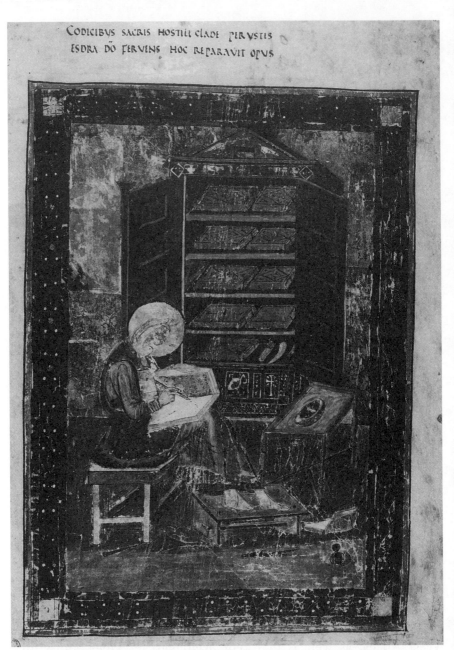

CODICIBVS SACRIS HOSTILI CLADE PERVSTIS
ESDRA DO FERVENS HOC REPARAVIT OPVS

12 Ezra. *Codex Amiatinus. Wearmouth-Jarrow, c. 700. Florence, Biblioteca*
Medicea Laurenziana, MS Laur. Amiatino I, c. 5. Photo: Ministero per i Beni e
le Attività Culturali

velopment of the early Middle Ages. But the conflicts inherent in these pairs were not always resolved in the same way. Different contexts demanded different artistic solutions, as three other early medieval English objects make apparent. The Codex Amiatinus ("Amiatine book") is so called because it was in the central Italian monastery on Monte Amiata for much of the Middle Ages. It is a manuscript of the entire Bible, written in the Northumbrian double monastery of Wearmouth and Jarrow around 700. Wearmouth-Jarrow was Bede's monastery; he entered at the age of seven, wrote his *History of the English Church and People* there, and was a monk there when the Codex Amiatinus was made. The manuscript is one of the largest of the entire Middle Ages: more than two feet high, eight inches thick, and weighing ninety pounds. The book is not only large, it is also fascinating and problematic. I will consider only one of its miniatures, the frontispiece to the Bible showing the Old Testament prophet Ezra seated in front of a book cabinet writing in a manuscript [12].

Wearmouth-Jarrow actually comprised two monasteries, St. Peter at Wearmouth, founded by a noble Northumbrian named Benedict Biscop, and St. Paul at Jarrow, founded at Benedict's direction by the Anglo-Saxon Ceolfrith. The Codex Amiatinus was made at Ceolfrith's command as a gift for the pope. The manuscript never reached its intended destination, for Ceolfrith died in France in 716 on the way to Rome to deliver it. It is remarkable that the newly literate Anglo-Saxons, who owed their literacy to the Roman missionaries, were now themselves making manuscripts to send back to Rome. But Rome held a special place in the hearts of the monks at Wearmouth-Jarrow, as the dedication of their churches to the two most important Roman saints shows. Christ's disciple Peter, considered the first pope, was the chief symbol of the Roman domination of the church; Paul, the most influential apostle, was believed to have met his death by martyrdom in Rome. By the fourth century the Roman tombs of both saints were marked by huge, prestigious churches. Benedict Biscop made a series of trips from Northumbria to Rome, no small achievement in the early Middle Ages given the distance and the natural barriers. Bede tells us he brought back books, paintings, relics of Roman saints, and a cleric to teach the English monks how to sing "according to the manner of the Roman usage." He also imported masons who

knew how to build "a church of stone after the Roman fashion which he always loved."[13] Rome was an ideal and an obsession for Benedict, but one with a concrete, physical presence at his monastery.

These Roman models had a profound effect. Even though it is an insular manuscript, the Codex Amiatinus has much more in common with the Gospels of St. Augustine than it does with the Book of Durrow. The most telling contrast is between the Ezra page in Amiatinus [12] and the man symbolizing Matthew in Durrow [6], which exhibits the characteristic flatness of traditional Anglo-Saxon forms. The man's head and body are seen directly from the front, his feet from the side, as if his form were determined by the cardinal points of the compass. No background indicates his place in space. In Amiatinus there is a greater variety of angles and possible motion. Ezra's body is seen more or less from the side, but the complex positions of his hands and feet suggest a much greater range of movement than does the figure in Durrow. The artist of the Codex Amiatinus used fore-shortening to render the furniture in the room: Ezra's chair, his footstool, the table to the right, the large book cupboard at the back of the image. This cupboard's doors show well both the insular artist's valiant attempts to indicate depth and his lack of comfort with the techniques for doing so. The doors sometimes seem to recede into depth, but at other times they appear to project forward, causing an unsuccessful flickering effect, like an optical illusion.

The forms of the Ezra miniature show its allegiance to the Mediterranean way of constructing a picture. So, too, does its aggressively literate iconography. Books are present; Ezra writes in one and a nine-volume Bible, spines carefully marked with titles, lies in the book cupboard. In fact, reading and writing are this miniature's subject, for Ezra played a crucial role in the history of literacy. Although the Jews had received writing early, in the tablets of the Law that God gave to Moses on Mt. Sinai, this did not make their culture literate; there was a considerable gap between writing's introduction and its spread. In ancient Israel, as in seventh-century England, the word arrived in a religious context but did not immediately become widely available. And as in England and Ireland, when Moses first brought writing to the Jews, the word was considered magical. It was enshrined rather than read; the tablets were placed out of sight in the

Ark of the Covenant, which was kept in the Temple with the other cult objects. The book was still a token of writing rather than a text to be read. Because this magical nature of Hebrew scripture had severely restricted its distribution, when the Temple was destroyed, so was God's text. The high priest and scribe Ezra saved the day because he was able to write out the word of God from memory (such mnemonic feats, astonishing to us, are typical of oral cultures). The Wearmouth-Jarrow monks probably saw Ezra as a kindred spirit, willing to go to any lengths in the service of the sacred word.

The Romanophilia at Wearmouth-Jarrow was not simply a matter of taste. The monastery's allegiance to Rome was worth demonstrating because it was not routine, and the Codex Amiatinus was an important part of that demonstration. Northumbria was converted to Christianity twice during the seventh century. The first, partial, conversion was by Roman missionaries moving northward in the wake of Augustine's arrival. A few years later, a second conversion was accomplished, this time by missionaries from Ireland. At just about the time England relapsed into paganism after the Saxon invasion of the fifth century, St. Patrick had converted Ireland to Christianity. The Christianity of the Irish monks who converted Northumbria was ultimately Mediterranean in origin, but because the religion continually evolved, it was Mediterranean Christianity of an earlier era than that practiced by Augustine and his followers. As a result, the Irish and Roman monks varied slightly in their religious practice, disagreeing on the correct date of Easter and the proper form of the tonsure. (The Irish shaved the entire front of the head, but the Roman monks preferred a round spot at the crown; the man of Matthew in the Book of Durrow [6] may sport an Irish tonsure.) These issues were disputed at a synod held in the northern English monastery of Whitby in 664. The Irish monks were defeated and withdrew to Ireland, leaving the field open to the Romans. The issues debated at Whitby cannot help but seem trivial to us now, and even if we remember that Easter is the most important Christian feast, it is hard to believe that other questions, of power and dominance, were not what was really in dispute. The extreme Romanness of the Codex Amiatinus is a sign of Wearmouth-Jarrow's desire to ally itself forcefully and publicly with the victors at Whitby.

Formally, the Book of Durrow and the Codex Amiatinus have nothing in common. But the two books share the peculiarly insular conception of the magic power of the word. Goody has written, "For non-literate cultures throughout the world, the magic of the written word derived . . . from its association with a priesthood and from the high prestige and technical achievements of the cultures of which it formed a part."[14] The Codex Amiatinus exemplifies both points. The formerly oral Anglo-Saxons were so immensely impressed by the literacy of the Mediterranean missionaries that they tried to duplicate or even surpass their achievements. To do this they depicted Ezra, the model of the literate monk. He wears the breastplate of the Old Testament priest as he uses the Mediterranean technology of writing, almost in illustration of Goody's words. In the Book of Durrow insular artists paid homage to the word by transmuting the foreign letters into their own shapes; in the Codex Amiatinus insular monks also honored the word, in this case by doing their best to imitate the foreign forms in which that word reached them.

The Codex Amiatinus makes clear that insular artists could manipulate style for ideological reasons. It thus puts the lie to those who argue that works like the Book of Durrow lack naturalistic forms because the artists simply could not do any better. (A small minority of scholars continue to believe that the Codex Amiatinus miniatures are too illusionistic to have been done by an Englishman. But visual culture is a matter of training the eye and the hand, not of having the right blood). The Codex Amiatinus is also unique. No other manuscript produced in England in the early Middle Ages has anything like its Mediterranean qualities. This is not surprising. Wearmouth-Jarrow was particularly fervent in its devotion to Rome, attempting to be more Roman than the pope. Although such miniatures might be fine for a papal gift, they would have been less successful in the real business of the English monks: running a church at home. Most Englishmen, monks and laymen, would have found the Codex Amiatinus strange. Early medieval English Christianity is characterized by a synthesis of the insular and Mediterranean traditions. The Book of Durrow exhibited an extremely insular form of that synthesis, the Codex Amiatinus a particularly Roman one. Two other Northumbrian works, the Lindisfarne Gospels and the Franks Casket, show how rich the middle ground between those two poles could be.

In the Lindisfarne Gospels, as in the Book of Durrow, each gospel is preceded by an evangelist portrait and a carpet page ([13] and [Plate II] are the examples from the Gospel of Matthew). The Lindisfarne manuscript was written (and perhaps decorated as well) by Eadfrith, bishop at Lindisfarne and a member of the monastic community there. Since Eadfrith became bishop in 698 and died in 721, the Lindisfarne Gospels are firmly dated; they are an exact contemporary of the Codex Amiatinus, made only forty miles away at Wearmouth-Jarrow. In certain ways the two books are remarkably similar, as is clear if we compare Ezra in the Bible [12] and Matthew in the Gospels. Both haloed men sit on a cushion placed on a wooden stool and write in open books. Even details in the two miniatures are almost identical: the way both men hold their books and pens, the construction of their wooden seats, and the position of their feet. There are iconographic differences (the book cabinet is missing in Lindisfarne; Matthew is accompanied by his symbol, a trumpet-blowing angel; and a mysterious man peeks at Matthew from behind a curtain), but most of these are the result of differences in the subjects of the two miniatures, since one miniature shows an Old Testament scribe, the other a New Testament evangelist.

The two images share much in terms of layout, but formally they are strikingly different, with the Lindisfarne Gospels more typical of insular art than the Codex Amiatinus. One crucial difference is in the handling of space. The Matthew miniature is much flatter than the Ezra page. Although the seat of Matthew's chair appears to recede diagonally back beneath his legs, the chair's side has been firmly anchored to the frame at the bottom left corner, with every angle a right angle. This desire to see the chair precisely from the side is like the handling of the man's feet in Durrow [6]. Also typically insular in Lindisfarne is the artist's refusal to use fine gradations of light and dark to indicate shadow; instead, the sharply delineated shadows in Matthew's cloak and the curtain form a decorative pattern of highly contrasting lines. Even more characteristic of the insular tradition are the carpet pages in Lindisfarne [Plate II], not found in Amiatinus.

Like all insular manuscripts, the Lindisfarne Gospels are very much concerned with the magic power of the word. Each gospel begins with an elaborate decorated page of almost illegible display script [14]. The special insular interest in writing and books also influenced

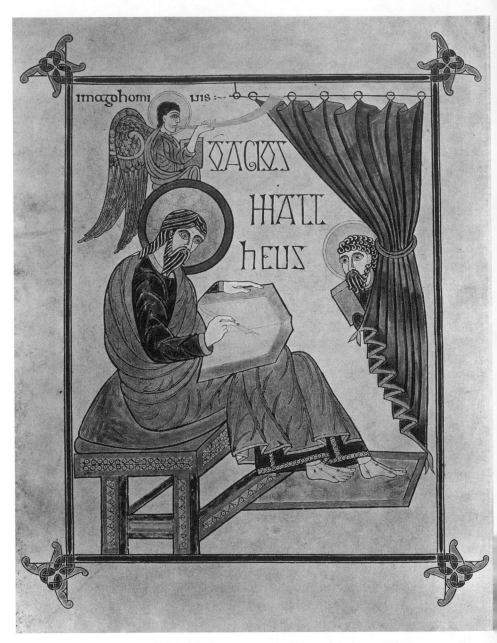

13 *Matthew. Lindisfarne Gospels. Lindisfarne, 698–721. London, British Library, Cotton MS Nero D. iv, fol. 25v. Photo: By permission of the British Library*

the Matthew miniature, which has two inscriptions. Near the top, in the uncial script used for the text of the gospels, the Latin words *"imago hominis"* [representation of a man] are written above and around Matthew's symbol. Below that, in a fancy display script, is the caption *"O Agios Mattheus"* [St. Matthew]. This inscription is curious because although it is in Greek (or pseudo-Greek), it is written in Roman characters. Greek was virtually unknown in early medieval England, but it had immense prestige as the language of the New Testament; this probably accounts for its use here. Because no one could read Greek, this inscription, like some of the text of these insular gospel books, was literally illegible. This caption is significant, but not in the usual way, with a particular word standing for a particular thing. Instead, the words carry meaning simply because they are words. This is another example of the insular transformation of the Mediterranean word, the magic power with which writing was invested when it was brought north.

In the Matthew page of the Lindisfarne Gospels, the word takes on a special importance because of its identification with Christ. As Matthew writes his gospel, a man holding a book emerges from behind a curtain. Like Matthew he is haloed, but he is smaller than the evangelist and is almost completely covered by the curtain. These visual signs indicate that he is less important than Matthew, and this argues against the usual identification of him as Christ. I believe instead that he is Moses. Crucial here is his closed book, which stands in clear contrast to Matthew's open one. Medieval Christians likened the Old and New Testaments to closed and open books, respectively. They believed that the closed mystery of the Old Testament was made accessible only by the coming of Christ, the very story told in the gospels. The relationship of the two Testaments was described by the apostle Paul in a series of metaphors involving reading and writing, metaphors that contrast the tablets of the Law received by Moses with Christ's Gospel. Christ is a letter "written not with ink, but with the Spirit of the living God; not in tablets of stone, but in the fleshly tablets of the heart" (2 Cor. 3:3; slightly adapted). Paul also tells of the veil that Moses put over his face when he came down from Sinai because he was glowing from his contact with God:

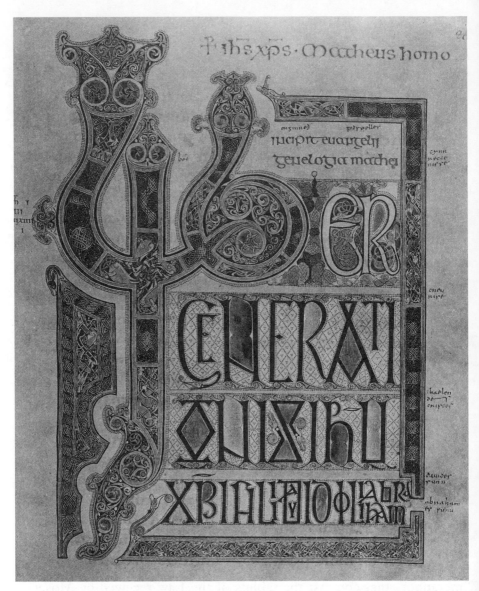

14 *Beginning of the Gospel of Matthew. Lindisfarne Gospels. Lindisfarne, 698–721. London, British Library, Cotton MS Nero D. iv, fol. 27. Photo: By permission of the British Library*

Up to the present day that same veil remains during the reading of the Old Testament. It is not lifted because it is made void in Christ. But up to the present day, when Moses is read, the veil is over [the Jews'] hearts. But when they shall be converted to the Lord, the veil shall be taken away. (2 Cor. 3:14–16; adapted).

Moses is veiled, his book is closed, but he is still worthy of respect. He appears at the beginning of the Lindisfarne Gospels to remind us of the venerable Old Testament. But because his law is old and has been superseded by Christ, he will appear no more (and this veiled figure, present at the beginning of the first gospel, is absent from the manuscript's other three evangelist portraits).

A final aspect of the words in the Lindisfarne Gospels, their role in defining space, deserves notice because it has implications for much early medieval art. In the traditional, Mediterranean construction of space, an image's border functions like a window, seemingly giving a view through the frame deep into space [1, 4, 12]. The illusion of the window is more convincing in some pictures than in others. In the St. Augustine Gospels, for example, it is called into question: How do the small narrative scenes between the columns relate spatially to the representations of Luke or of his symbol, the ox [4]? As our mind raises these questions, the three-dimensional space becomes progressively more compressed, a compression perhaps appropriate in a manuscript, where the physical act of turning the pages reminds us that they cannot literally be windows.[15] But the squeezing of space in the Italian evangelist portrait is modest in comparison to that of the Lindisfarne Gospels. There, the frame does not define any sort of a window; it simply separates inside from outside. The area inside the frame is tinted very slightly (so slightly that it is not visible in this illustration), but otherwise the frame does nothing to create space. In fact, the miniaturist has included a series of carefully constructed details to flatten the space further. The curtain hangs from the top frame, indicating that it is in the same plane as the frame. Yet the curtain is overlapped by Matthew's footrest, which the perspective of his chair suggests is quite far back in the miniature. The result is a visual paradox that squeezes space from the miniature. The strongest flattening element of all is the words. Written letters and words do not float in deep space; they sit on a flat surface, emphasizing that flatness.

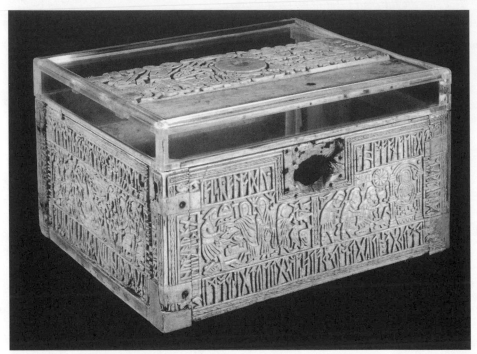

15 Franks Casket. Overall view showing front, top, and left side. England, c. 700. London, British Museum. Photo: The British Museum

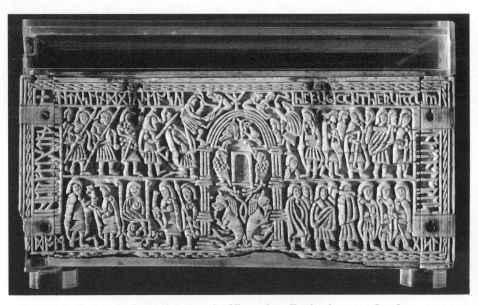

16 Franks Casket. Back panel with sack of Jerusalem. England, c. 700. London, British Museum. Photo: The British Museum

The inscriptions inside the frame in the Lindisfarne Gospels shatter any illusion that we are seeing through a window. In the Codex Amiatinus, by contrast, although words were also required (the image of Ezra was unusual and needed explanation), they were placed outside the frame, in the margin, to preserve the illusion [12].

The Lindisfarne Gospels synthesize two currents in early medieval art: northern nonrepresentational forms and Mediterranean figurative, narrative art. They more or less split the difference between Sutton Hoo and the Codex Amiatinus, recognizing that the most effective insular Christian art uses insular forms to express Christian pictorial content. A similar synthesis, but taking a very different form, characterizes another insular object, the Franks Casket. This small box (its name comes from its nineteenth-century owner, Augustus Franks) is a puzzle, as even a cursory description indicates. Made of whalebone, the top and all four sides are richly carved, covered with an exceptionally large number of people and objects [15, 16]. Each scene is accompanied by inscriptions and captions in an eccentric mixture of Latin and Old English, written in an even more diverse array of scripts. Some inscriptions use Roman characters; others are runes, a peculiarly northern European alphabet made up of sticklike letters used to write the Germanic and Scandinavian vernaculars. The runes appear in both conventional and coded forms, and to further the confusing Babel of languages, some of the inscriptions are retrograde, reading from right to left rather than in the expected direction.

Like the inscriptions, the scenes on the Franks Casket draw from a range of sources and traditions. The idea of a synthesis of Germanic and Mediterranean, Christian and pagan elements has been helpful in our analysis of insular art, but the Franks Casket pushes that notion to its limits. Not all of the scenes on the casket have been firmly identified: Although all are accompanied by inscriptions, our ability to understand the iconographic program is hampered by wild disagreements among scholars about the correct reading of the runes. (The Anglo-Saxonist D.M. Wilson has discovered what he calls the First Law of Runodynamics: "For every inscription there shall be as many interpretations as there are scholars working on it."[16])

Still, the identification of some of the scenes is beyond doubt. The left side of the casket (just visible in [15]) shows the ancient Roman

myth of Romulus and Remus, the twin brothers who founded the city of Rome and were nourished by a she-wolf. The subject is Mediterranean, but the inscription is in Old English and written in runes. The scene on the back of the casket is also from Roman history but of a very different period [16]. It represents the sack of Jerusalem in A.D. 70 by the Roman emperor Titus, a crucial moment for the Jews because the Second Temple was destroyed. The Temple, or perhaps the entire city, is represented by the large arch in the center of this panel; the Ark of the Covenant sits in the center of the arch. The blending of traditions on the Franks Casket is strikingly apparent in the inscription at upper right, "*Hic fugiant Hierusalim afitatores*" [Here the inhabitants flee Jerusalem]. Talking about Jews in the Latin language, it is written partly in Roman, partly in runic characters.

Not all the images on the Franks Casket are from the Roman tradition. The front panel pairs scenes from Germanic myth and the New Testament. On the left side is the pagan story of Weland the Smith; on the right, a depiction of an important Christian event, the Magi bringing gifts to the newborn Christ. What these scenes have to do with one another is far from clear. The juxtaposition invites us to find parallels (for example, both involve treasure and gift giving, since Weland was a goldsmith), but the meaning of these parallels has yet to be fully characterized by scholars. The inscription on the front, unlike those on the top and sides, does not refer to the carvings' subject matter; rather, it is a riddle about whalebone, the material from which the box is made.[17] Riddles are a typical form of Anglo-Saxon literature, and it is likely that this early medieval insular interest in puzzles informs not just the inscriptions but the Casket as a whole; our difficulty in interpreting the iconographic program stems from the maker's desire to provide us with a visual riddle. Whatever its precise meaning, the Franks Casket shows that by the eighth century early medieval art was coming to terms with its component traditions: the Christian, the classical, and the Germanic. Likewise it had found its form, a simplified figure style, often supplemented with abstract elements. And the introduction of words into the work of art was commonplace, perhaps almost required.

2

Art in the Service of the Word

espite (or because of) the sanctity of the Christian word, medieval artists in northern Europe were willing to deform the letters that make up that word. Letters could be decorated, as in the insular gospel books; they could also serve as supports for pictures. A huge initial *C*, the first letter of the Latin word *"Concede"* [grant], dominates a page from a manuscript known as the Drogo Sacramentary, made in the northern French city of Metz around the middle of the ninth century for Drogo, Metz's archbishop [17]. The maker of the manuscript broke up the word, moving the initial down and to the right (the rest of *Concede* is on the second line of text; the first is devoted to a title). Most surprisingly, he used the initial as the frame for several figurative scenes, creating what is called a historiated initial. At top right, the Virgin Mary lies in bed, having just given birth to Christ; Joseph is beneath her; and in a small, separate compartment somewhat to the left, the infant Jesus is watched over by the ox and ass. Toward the middle of the letter three shepherds are about to learn of Christ's birth. And at the bottom of the *C* the Christ child receives his first bath (an event not in the Gospels, but known from later medieval legends).

The text is similarly disrupted on another page of the Drogo Sacramentary [18]. A large initial *T* introduces two words, *"Te igitur"* [You, therefore]. Instead of reading from left to right and top to

17
Initial C. Drogo
Sacramentary.
Metz, before 855.
Paris, Bibliothèque
nationale, ms. lat.
9428, fol. 24v. Photo:
Cliché Bibliothèque
nationale de
France, Paris

bottom, however, the text begins in the center of the page with the huge *T*, moves right and down *(e i)*, then back up to the left for the *gi* of *igitur*. The last three letters of that word are also arrayed symmetrically about a central *t*, mirroring the construction of the page as a whole. The nonclassical attitude toward the word and the individual letter in the Drogo Sacramentary is especially striking because in other ways the manuscript depends heavily on the classical tradition. The forms of the letters are closely copied from ancient Roman models (although in antiquity letters were never used as supports for pictures). Indeed, the Sacramentary is one of the chief monuments of what is known as the Carolingian renaissance, an attempt by the Frankish king Charlemagne and his followers to reform learning by copying antique models. Yet despite this, nonclassical concerns for decoration and symmetry were allowed to jeopardize legibility.

18
Te igitur. *Drogo Sacramentary. Metz, before 855. Paris, Bibliothèque nationale, ms. lat. 9428, fol. 15v. Photo: Cliché Bibliothèque nationale de France, Paris*

How was this possible? Some of the answers lie in the manuscript's text. A sacramentary contains the prayers said during the mass, the most important part of the Christian liturgy, when Christ's sacrifice is reenacted through the Eucharist, the transformation of bread and wine into Christ's body and blood. The Te Igitur is read during every mass, so any priest would have memorized its words long before he ever laid eyes on this manuscript; the page functions as an aide-mémoire rather than as a text to be read in the usual way. Another explanation for the illegibility of the Drogo Sacramentary is the special nature of the Christian word, which is identified with Christ himself. During the mass the word is presented to the congregation twice, first in its conventional textual form, as the gospel is read, and then again in the physical form of the Eucharist, as Christ's body is consumed. The liturgy depends on the word; hence a desire, perhaps an obligation, to decorate that word.

The mass reenacts Christ's sacrifice on the cross. The central mass prayer, the Te Igitur, begins with the cross-shaped letter *T*. For the early Middle Ages, with its often complete assimilation of word and image, this was almost too good to be true. In the Drogo Sacramentary the *T* is decorated with Old Testament scenes believed to foreshadow Christ's sacrifice; it is both a letter and a support for images, with the two functions intertwined but separable. In a late-tenth-century German sacramentary, the exceptionally supple early medieval attitude toward the letter was pushed to its limits, as the initial of *Te igitur* was actually turned into a depiction of the crucifixion [19]. Here the word has become the image. According to the classical conception, letters were arbitrary, conventional signs denoting particular sounds; clear rules defined their form, rules that needed to be maintained for effective written communication. In the early Middle Ages, however, the letter became a magic sign of Christ. In this sacramentary the *T* is no longer the abstract signal of a sound; rather, it is a visual, illusionistic representation of the cross. The transformation from letter to picture is made clear by the shading around the upright and crossbar, which indicates that the cross is seen slightly from below, as if we were standing at its foot and looking up at the crucified Christ. The word has become flesh.

Although the form of the mass has evolved with the history of Christianity, two elements have remained crucial: the liturgies of the word and the Eucharist. In the liturgy of the word, texts are read, principally from the New Testament but sometimes also from the Old Testament or the lives of the saints. The liturgy of the Eucharist transforms bread and wine into Christ's body and blood. During the early Middle Ages, as in the Protestant Reformation, the precise nature of this transformation was debated: Was it literal or only symbolic? Whatever the answer, the transforming event was of the utmost importance. Thus the books and utensils made for the mass are among the most precious and sumptuous of all early medieval works. Those objects, and the spaces in which they were used, are the subject of this chapter.

Two carved ivories, almost certainly made as the covers for a sacramentary, illustrate the two parts of the mass [20, 21]. Scholars disagree about the dates of these works and where they were made, some

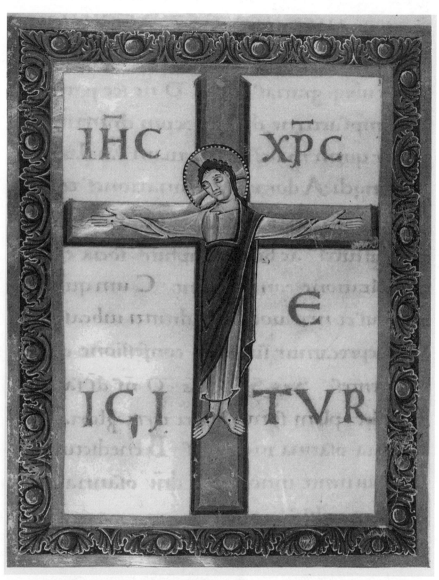

19　Te igitur *from a sacramentary. Reichenau, late tenth century. Oxford, Bodleian Library, MS Canon. liturg. 319, fol. 31v. Photo: The Bodleian Library, University of Oxford*

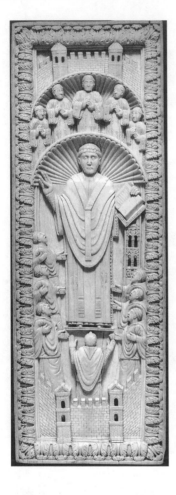

20 *Ivory with depiction of the mass. Northern France, c. 875 or Germany (?), c. 1000. Cambridge, Fitzwilliam Museum. Photo: Fitzwilliam Museum, Cambridge*

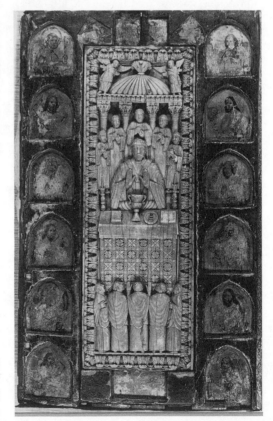

21
Ivory with depiction of the mass. Northern France, c. 875 or Germany (?), c. 1000. Frankfurt, Stadt- und Universitätsbibliothek, MS Barth. 181 Photo: Stadt- und Universitätsbibliothek

placing their creation in northern France in the late ninth century, others preferring a date around the year 1000 and an origin in Germany or northern Italy. Although the details of this argument need not concern us, it is a matter of some interest that there is a debate at all. Style, the ways in which figures or things are rendered in a work of art, is a traditional art-historical tool for determining when and where a work of art was made. Works of art made at the same time and in the same place are usually similar in appearance; for example, almost all of the paintings made in Florence in the fifteenth or sixteenth centuries share certain features and look different from works made in Venice at the same time. Although it is very difficult to understand precisely what style is (this is sometimes known as the riddle of style), it is often a useful art-historical tool.[1] As we saw in Chapter 1, however, style in the early Middle Ages was not the product of an invisible hand guiding artistic development; rather, it was manipulated by artists and patrons. The forms in the Codex Amiatinus, for example, looked vastly different and had a completely different meaning from the forms in the Lindisfarne Gospels, even though the two manuscripts were made at the same time and in almost the same place. Precisely because early medieval style was freighted with so much meaning, it often cannot be used as a reliable tool to date or locate a work.

One ivory [20] depicts the liturgy of the word said by a priest, probably Gregory the Great, who was believed to have codified the mass texts and music (for this reason we still speak of Gregorian chant). The priest, elaborately dressed in complex liturgical vestments, lifts a book from the lectern; engraved on its pages are the first words of Psalm 24 ("To thee, O Lord, have I lifted up my soul"), a verse sung at the mass on the first Sunday of Advent, the period leading up to the important feast of Christmas. It is a sign of the importance of the word in the early Middle Ages that the artist has not just indicated the appearance of words on the book but has so meticulously engraved the biblical text that it remains legible to this day; God's word was too significant to be sketched. Gregory is surrounded by clerics. Those at the bottom of the ivory, mouths wide open, assist him in the chant that introduces the gospel readings. The matching ivory depicts the liturgy of the Eucharist [21]. The priest, hands raised, greets the

community. Behind him is a ciborium, a canopy over the altar supported by four columns. Clerics stand beneath the ciborium and in front of the richly decorated altar, which is covered with a cloth on which sit the mass implements: gospel book, chalice for the wine, paten for the bread, and sacramentary, open for the priest to say the canon of the mass (the familiar words *Te igitur* are visible in the book).

Because of their importance as receptacles for Christ's blood, early medieval liturgical chalices were made of precious materials and richly decorated. The Ardagh Chalice, made in Ireland around 800 [22], transmits back to metalwork the interlace and other abstract patterning we encountered in Chapter 1 in the insular gospel books (recall that these forms were originally developed in the pre-Christian metalworking tradition exemplified by the Sutton Hoo treasure). Chalices were accompanied by patens, plates for the Eucharistic bread.[2] A ninth-century paten made on the Continent for Charles the Bald, Charlemagne's grandson, is an unusual object [23]. The central part, a disk of serpentine, a green stone, inlaid with golden fish, is not early medieval at all; it was made in the Mediterranean sometime between the late Roman Republic (first century B.C.) and the late antique period of the fourth century, so it was probably not originally Christian. Some pagan works of art were much admired in the early Middle Ages, particularly if, as in this case, they were made of precious materials. In the third quarter of the ninth century, northern French goldsmiths working for Charles placed a rim of gold inlaid with semiprecious stones around the serpentine disk, transforming the pagan piece into the holiest of Christian objects. The fish inlaid on the disk, originally meant to be frolicking across a serpentine sea, became in the Christian context a reference to Christ, who from earliest times had been symbolized by a fish (based on a Greek acrostic of his name and honorifics). The early medieval artist and his audience transformed the meaning of an antique work of art by appropriation, a transformation somewhat akin to the early medieval disruption of classical letter forms.

A similar process is at work in another piece of liturgical art, the altar cross known as the Lothar Cross [Plate III]. Although it takes its name from the seal of the Carolingian king Lothar II (Charles the Bald's nephew) near its base, it was actually made around 1000 for one

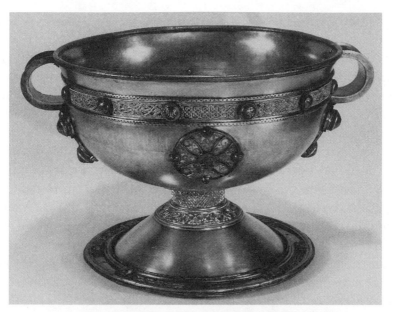

22 *Ardagh Chalice. Ireland, c. 800. Dublin, National Museum of Ireland.*
Photo: National Museum of Ireland

23 *Paten of Charles the Bald. Mediterranean, classical or late*
antique period; court school of Charles the Bald, third quarter of
the ninth century. Paris, Musée du Louvre. Photo: Réunion des
Musées nationaux

of the Ottonians, the royal dynasty that succeeded the Carolingians in Germany. Lothar's seal is not the most striking object reused on the cross. Precisely at the center, where we would expect to find the head of Christ (and indeed, where his head appears engraved in gold on the cross's back), is a spectacular cameo of the first Roman emperor, Augustus Caesar.[3] As with the paten of Charles the Bald, the pagan classical work has been reinterpreted by the Christian patron and his artists. For them, the cameo refers not to Augustus but to two other emperors, the heavenly king Christ and the earthly Ottonian ruler for whom the cross was made. Although this iconographic program is not incomprehensible, the image of an ostentatiously pagan ruler in the center of a Christian object sitting on the altar is as surprising now as it must have been in the early Middle Ages.

The mass books kept on the altar were also preciously decorated. This decoration included not only the paintings inside the manuscripts but their covers as well. Carved ivory was often used for such covers; for the most luxurious books, gold might be employed, as on a gospel book made for Charles the Bald [24], probably by the same group of artisans who fashioned the rim for his paten. Known as the *Codex aureus* ("golden book"), not only is the front cover made of beaten gold but the entire text of the gospels is written in golden ink, a difficult and expensive technique (for pages from the manuscript see [42, 43]). The center of the cover shows Christ enthroned on the globe of the world and holding on his knee a book inscribed with the words "I am the way, and the truth, and the life. No man cometh to the Father, but by me" (John 14:6).

There could hardly be a more apposite verse, since these words apply both to Christ and to the book he holds on his lap, the same book that is beneath this cover. Without the text of the Gospels, through which Christ's teachings are transmitted, no man of the early Middle Ages could come to God. And because books and literacy were rare, very few in the early Middle Ages could come to the Gospels except through participating in the mass, for which the *Codex aureus* was made. Surrounding the enthroned Christ are depictions of the four evangelists writing their gospels and four scenes from their stories of Christ's life. The cover is also decorated with large semiprecious stones set in elaborate mounts. These stones enhance the sumptuous-

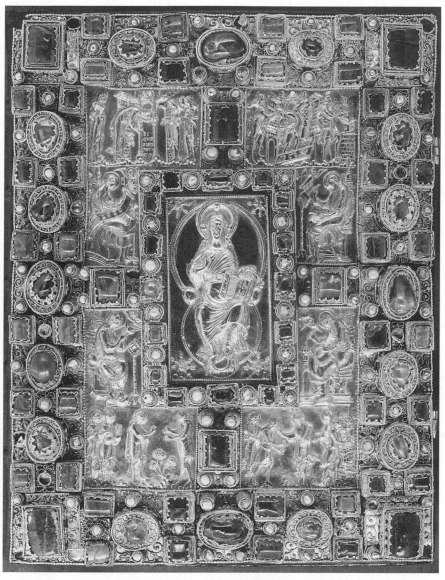

24 *Front cover of the* Codex aureus. *Court school of Charles the Bald, c. 870. Munich, Bayerische Staatsbibliothek, Clm 14000. Photo: Staatsbibliothek*

ness of the work and also project up from the cover and protect it
when the book is open. Such protection was an absolute necessity be-
cause the figures on the cover, made of thin gold foil hammered from
the back to form the figures, are exceptionally fragile. It is a sign of
the esteem with which the *Codex aureus* was held that it has survived
in almost perfect condition.

It was not just the items sitting on the altar that were made of pre-
cious materials. The altars themselves were decorated, as were the
priests. Written sources report large numbers of highly prized silk
liturgical vestments in a dazzling array of colors, although almost
none have survived because of the fragility of textiles. The altars
themselves have fared better. The front of the altar shown in [21] is
decorated with an abstract pattern of flowers. It is hard to tell of what
material this altar is meant to be made, but some were of the most
valuable metals, such as an early-eleventh-century golden altar frontal
with a standing figure of Christ flanked by three angels and St. Bene-
dict [25]. At Christ's feet kneel the Ottonian emperor Henry II and
his wife Kunigunde, so tiny that they are almost invisible. (This altar,
and another like it [59, 60], are discussed in Chapter 5.)

The influence of the Old Testament on Christian theology and
thought also affected the altar and its decoration. As with everything
else, Christians saw their liturgical practice as surpassing that of the
Jews: Whereas the Jews of the Old Testament had actually sacrificed
animals to God, the Christians used the bloodless sacrifice of the
mass. But the Christian relationship to the Old Testament is complex,
since Christ is believed both to have superseded and fulfilled the Old
Testament. Thus, the Christian liturgy sometimes depended on the
rituals described in the Old Testament. Since the Ark of the Covenant
had a golden crown hanging above it (Exod. 25:11), so did many
Christian altars. The altar crown shown in [26] was made for the
Visigothic king Receswinth, who ruled in Spain. It was excavated near
Toledo and had probably been buried to protect it from the Muslims
who invaded Spain early in the eighth century. The evidence for Re-
ceswinth's patronage is the letters dangling from the crown, which
spell out in Latin "King Receswinth gave this." As with many early
medieval liturgical objects, the patron wished to make his patronage
known to God and to the priests who had access to the altar, in the

25 *Altar frontal of Henry II. Germany, first quarter of the eleventh century. Paris,*
 Musée national du moyen-age. Photo: Réunion des Musées nationaux

26
Receswinth crown. Toledo,
653–672. Madrid, Museo
Arqueológico Nacional. Photo:
Archivio Fotográfico, Museo
Arqueológico Nacional

hope that through them he would be able to obtain divine favor in return for his gift.

Little of the ecclesiastical or secular architecture from the period covered by this book has survived. As churches fell into ruin, were destroyed (typically because their wooden roofs burned), or became outmoded, they were replaced by new structures, usually on the same site as the old one. This required the destruction of the original. By contrast, when a monastery received a new gospel book or a new chalice, it was not necessary to discard the one being replaced; indeed, quite the opposite, since these old objects were treasured and preserved. As a result, the liturgical objects discussed in this chapter have had a much higher survival rate than the spaces in which the liturgy was performed. Enough of the spaces of the word remain, however, for us to get an idea of them.

Throughout the Middle Ages the basic church building was the hall-shaped basilica. An early medieval example is the early-eleventh-century Church of St. Michael at Hildesheim in northern Germany ([27]; for a plan of a typical medieval basilica see [28]). Basilicas have an entrance facade, almost without exception in the west, and at the opposite, eastern, end is an apse, a semicircular sanctuary sheltering the altar for the divine service. This orientation of the church associated the rising sun, symbolic of Christ's resurrection, with the altar, where Christ's death was daily reenacted. The rectangular area between entrance and apse, the nave, could be of varying length and width and was sometimes flanked by two or even four aisles. The nave connected the door to the most important part of the building and gave the basilica its characteristic longitudinal axis. In the early Middle Ages, when stone vaulting was rarely used, such buildings were typically covered with a simple peaked timber roof, much like that on many of today's houses.

The basilica's popularity as a building type is easy to understand; it was simple to construct and highly adaptable in size and scale. More important, it was well suited to the Christian liturgy, since the basilica's layout directed the viewer's attention to the altar as soon as he stepped through the door. In a church that served a large populace, the nave sheltered the worshippers, while the clergy or monks gathered around the altar. In churches without large congregations, the

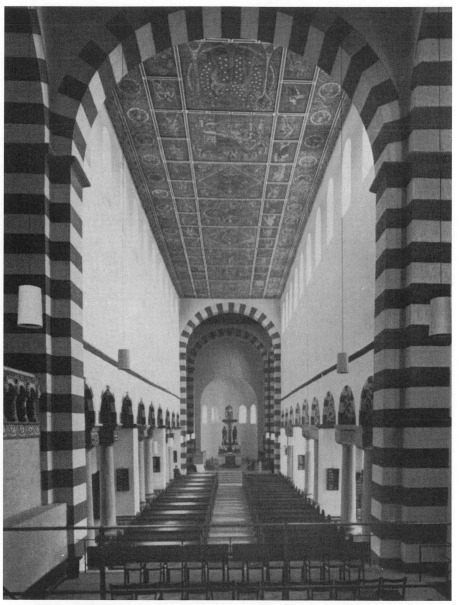

27 Church of St. Michael, Hildesheim. View looking east from nave. Early eleventh century. Photo: Centrum Kunsthistorische Documentatie, Katholieke Universiteit Nijmegen

nave could be used as a space for additional altars, part of the com-
plex processional liturgy developed in some areas. A final reason for
the widespread popularity of the basilica in the early medieval West
was its prestige as a building type. In the early fourth century, when
the Roman emperor Constantine converted to Christianity and
churches for the first time began to be built on a large scale, they
took the form of basilicas. The basilica had been used by the pagan
Romans for all kinds of public buildings. It was a common and there-
fore relatively neutral architectural form; as a model for the first
monumental Christian churches it was much preferable to the tem-
ple, with its obvious pagan associations. The early Roman basilicas,
especially that of St. Peter in Rome, were the most important
churches in Christendom, so the basilica was a well-respected archi-
tectural type throughout the Middle Ages. Although Old St. Peter's,
the church built on the site of the present-day Vatican church of St.
Peter's, lies chronologically and geographically outside the scope of
this book, it warrants brief discussion here because of its importance
as a model.

Constantine had ordered the construction of a church over the
tomb of Peter, the disciple of Christ who had been martyred in Rome
in the first century [28]. Whereas Romans shunned even their hon-
ored dead, Christians cultivated them, typically building their
churches over the tombs of revered Christians, the saints. The bones
of the saints were believed to have special power, power that could be
transferred to objects that touched them. At St. Peter's the altar was
directly above the saint's tomb. The access to the relics was described
by Gregory of Tours:

> The tomb is located beneath the altar and is quite inaccessible. Who-
> ever wishes to pray comes to the top of the tomb after unlocking the
> railings that surround the spot; a small opening is exposed, and the per-
> son inserts his head in the opening and requests whatever is necessary. If
> someone wishes to take away a blessed relic, he weighs a little piece of
> cloth on a pair of scales and lowers it into the tomb; then he keeps vigils,
> fasts, and earnestly prays that the power of the apostle will assist his
> piety. What happens next is extraordinary to report! If the man's faith is
> strong, when the piece of cloth is raised from the tomb it will be so

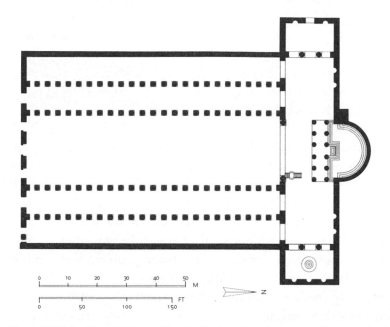

28 Plan of Old St. Peter's, Rome. First half of the fourth century. (Redrawn by I.
 Senagama after A. B. Gardin)

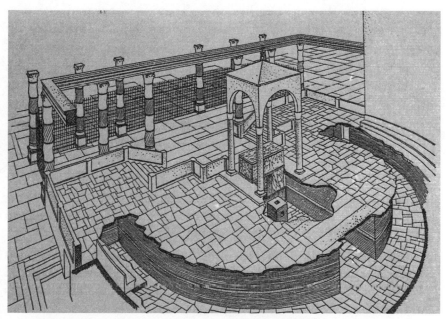

29 Old St. Peter's, Rome. Drawing showing Gregory the Great's renovation of the
 altar area. c. 600. Photo: Esplorazioni sotto la confessione di San Pietro in
 Vaticano, I, fig. 141 (Vatican City, 1951)

soaked with divine power that it will weigh much more than it weighed
previously; and the man who raised the cloth then knows that by its
good favor he has received what he requested.[4]

This cumbersome procedure could not satisfy the many pilgrims who
wished to get close to Peter's relics. Around 600, soon after Gregory of
Tours wrote his description, Gregory the Great renovated St. Peter's
with an eye to making the saint's tomb more accessible. He raised the
altar and built a passage underneath it to allow the faithful contact
with the relics even while the altar was otherwise being used [29].
Gregory's ingenious solution to a common problem was much copied
north of the Alps in the early Middle Ages.[5]

Few early medieval buildings have survived; even fewer have sur-
vived with their original decoration intact. But archaeological evi-
dence and textual descriptions let us know that these spaces for the
word were as richly decorated as the precious mass utensils used in
them. The layout of the basilica left large expanses of blank wall in
the nave, typically broken only by relatively small windows. In the
fourth-century Roman churches, these areas were covered with nar-
rative scenes from the lives of Christ and the saints or the stories of
the Old Testament in fresco and mosaic. This Roman model was fol-
lowed north of the Alps. The Church of St. George at Oberzell on
the Reichenau, a small island in Lake Constance on the border be-
tween Switzerland and Germany, has retained its early medieval nave
frescoing [30]. The church was built at the very end of the ninth cen-
tury, but the decoration dates for the most part from around 1000.
The nave walls are divided into three pictorial zones separated by
decorative motifs. This tripartite division was common, another
legacy of the prestigious Roman basilicas. At Oberzell the lowest
zone, between the arches, depicts the abbots of the Reichenau
monasteries. Above that is the major decorative expanse of the un-
broken wall, with large panels showing Christ's miracles. Between
the nave windows are the New Testament apostles, who preached
Christ's word, and Old Testament prophets, who predicted Christ's
coming.

Although the frescoes have faded badly with time, they give at least
a sense of the exceptional richness of such interiors. It is probably

30 *Church of St. George, Oberzell (Reichenau). View looking east showing nave and apse. Late ninth century (church) and c. 1000 (frescoes). Photo: Foto Marburg/ Art Resource, New York*

paintings like these that Gregory the Great had in mind when he compared pictures to books for those who cannot read; the large images at Oberzell are easily visible to anyone standing in the nave, literate or not. The subjects of the frescoes, the miracles of Christ, would have been familiar to a nonliterate audience from the gospel readings at mass and from sermons. But even so, the images are not allowed to stand entirely by themselves; the Oberzell frescoes are accompanied by inscriptions, known as tituli, that describe and comment on what is depicted. These tituli (one of which is visible in [30] around the arch leading into the apse) meant that at least part of these books of the illiterate would remain closed to those who could not read.

Not all early medieval churches were basilicas; some were centrally planned, dominated not by an axis but by a single central point or area. The most famous early medieval example is Charlemagne's palace chapel at Aachen, part of a large complex established by that ruler around 790 [31–33]. The chapel has two storeys, and a ringlike corridor surrounds the open central space on each level. A small rectangular apse at the east end sheltered the altar, giving the Aachen chapel an axis, but because of the central plan, this axis did not dominate the space as it did in the basilicas. (The present apse at Aachen is a thirteenth-century Gothic addition.) Charlemagne's throne was in the second-floor gallery, directly opposite the apse; the emperor could sit there, surrounded by courtiers, and see both the mass and the congregation gathered on the ground level.

Einhard, a courtier who wrote a biography of Charlemagne in the early part of the ninth century, tells of that ruler's special concern for the church at Aachen:

With great piety and devotion Charles followed the Christian religion, in which he had been reared from infancy. For this reason he constructed a church of stunning beauty at Aachen and adorned it with gold and silver, with lamps, grillwork, and doors made of solid bronze. When he could not obtain the columns and marble for this building from any place else, he took the trouble to have them brought from Rome and Ravenna. He made sure that his church was supplied with such an abundance of sacred vessels made of gold and silver and with such a great

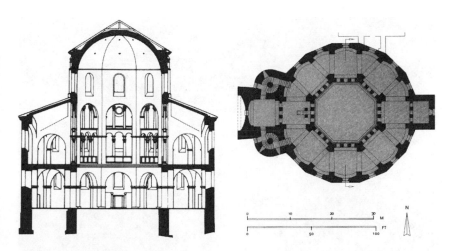

31 *Palace chapel of Charlemagne, Aachen. Plan and cross section. c. 790–805.*
(Redrawn by I. Senagama after A. B. Gardin)

number of clerical vestments that, indeed, in the celebration of the Mass
not even those looking after the doors, who hold the lowest of all eccle-
siastical orders, found it necessary to serve in their normal clothes. He
very carefully corrected the way in which the lessons were read and the
psalms sung, for he was quite skilled at both.[6]

Charlemagne took special care with the decoration of the Aachen
chapel, but he was also concerned to have the divine liturgy said cor-
rectly; as usual, word was as important as image in the early Middle
Ages. Indeed, among Charlemagne's most significant legacies are the
books produced for him and the texts edited and written at his direc-
tion. As Einhard makes clear, this was done not out of an academic
concern for philological accuracy but from a religious desire for theo-
logical exactitude. When dealing with God's word, extreme care was
required to get every letter right.

Although the gold and silver liturgical furnishings of the palace
chapel have long since been lost, the bronzework is still intact; the
railings are visible in [32]. Just behind the railings are columns. Ein-

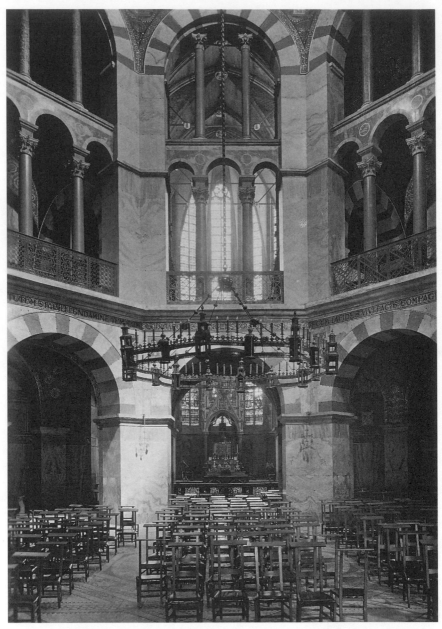

32 Palace chapel of Charlemagne, Aachen. View from center of floor up to gallery.
c. 790–805. Photo: IRPA–KIK, Brussels

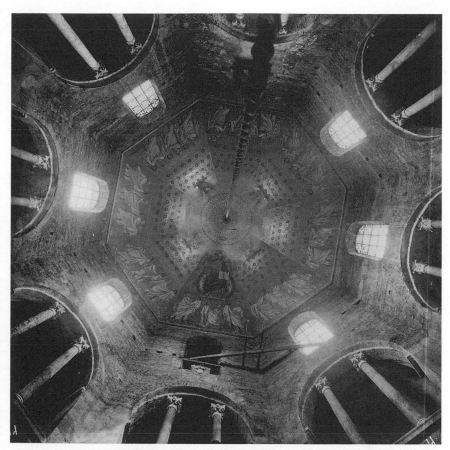

33 *Palace chapel of Charlemagne, Aachen. View from center of floor up to dome.*
c. 790–805. Photo: Foto Marburg/Art Resource, New York

hard tells us an unusual fact about these columns: They came from
Italy. Although Einhard writes that more local products were simply
unavailable, the choice of Rome and Ravenna as sources signals a
more complex program. Rome was the imperial capital both of the
pagan Caesars and, far more important for Charlemagne, of Constan-
tine and his Christian successors. In 330, when Constantine moved
the capital to a new city that he named after himself (Constantinople,
now Istanbul in modern Turkey), the center of imperial power shifted
far to the east. The Byzantine Empire was established, but imperial

control of Western Europe was soon lost to a variety of other groups. In the sixth century the Byzantine emperor Justinian used the Adriatic city of Ravenna as a foothold in an attempt to reconquer Italy. Justinian's ambition was never fulfilled, but one of the permanent signs of his attempted reconquest was the magnificent church he built in Ravenna, San Vitale.

San Vitale was a direct architectural model for Aachen, but Charlemagne was not content with simply copying the imperial monuments of Ravenna. He actually brought pieces of them to Aachen. Charlemagne used these borrowed elements (art historians call them spolia, spoils) to invoke the two great imperial models he knew, Rome and Byzantium. On Christmas Day 800, just a few years after the construction of his chapel had begun, Charlemagne himself was crowned Roman emperor, establishing a northern European empire as a rival to Mediterranean Byzantium. What Charlemagne accomplished first with spolia at Aachen, he later accomplished politically and ceremonially with his imperial coronation.

The use of spolia is a characteristic early medieval practice—the paten of Charles the Bald, the Lothar Cross, and the palace chapel at Aachen are all examples. But spoliation was not limited to the early Middle Ages. Although the visual culture of that time was vastly different from today's, there are some striking resonances between the early medieval and modern understanding of art. In the 790s Charlemagne had spoils brought from Rome and Ravenna for his palace chapel. Precisely one millennium later, in 1794, the French Revolutionary Army invading the Rhineland had those same columns, along with the bronze railings, removed from the chapel at Aachen and taken to the Louvre in Paris. They were spoils of their victory over the mighty Prussians, who controlled Aachen, and more important, a sign that power had passed from the medieval clerics and kings represented by Aachen to the modern secular, democratic people championed by the French Revolution.

A few years later, with the defeat of the Revolution and Napoleon's rise to power, the Aachen columns, now in the Louvre, changed their meaning again. Napoleon, who styled himself a new Charlemagne, saw them as symbols of the imperial glory he was restoring to France. After the defeat of Napoleon in 1815, most of the columns were re-

turned to Aachen. But their removal and subsequent recapture had so amplified their significance that the original plan for their return to Aachen was not to restore them to Charlemagne's chapel but to put them into a monument to the Prussian victors. Although cooler heads prevailed and the columns were replaced in the chapel, this plan indicates that spoliation is not just an early medieval phenomenon. (As does the fact that although France and Germany are now close allies, some of the Aachen columns remain in Paris.)[7]

Spoliation indicates how complex visual meaning could be in the early Middle Ages. Such complexities, which belie the simplicity of Gregory the Great's equation of pictures with words, are the subject of Chapter 3.

3

Books for the Illiterate?

⊹⟫⊜⟪⊹

Meaning in Early Medieval Art

n his letter to Serenus, Gregory justified pictures by saying they were like texts. But this simple theory of images is insufficient. Sometimes images did mimic the word, but at other times pictures did things words could not. This chapter examines the ways, verbal *and* visual, in which early medieval art conveyed meaning.

Pictures and texts are alike in that both can tell stories, and one of the most common types of early medieval art was narrative. Storytelling art could consist of isolated images or narrative cycles made up of several scenes. It is in these image cycles that pictures most closely approach text and most nearly become Gregory's books of the illiterate. Illustration [34] shows the frontispiece to the Vivian Bible, a large, richly illustrated one-volume Bible made for Charles the Bald in 845 as a gift from the monks of the monastery of St. Martin at Tours and their abbot, Count Vivian. The miniature depicts how, in the late fourth century, St. Jerome translated the Bible from the original Hebrew and Greek into Latin. It narrates pictorially the story of how the Word came to be.

The page is separated by tituli into three horizontal zones or registers. The top register comprises two scenes, but the division between them is not as clearly delineated as it would be in a modern pictorial

71

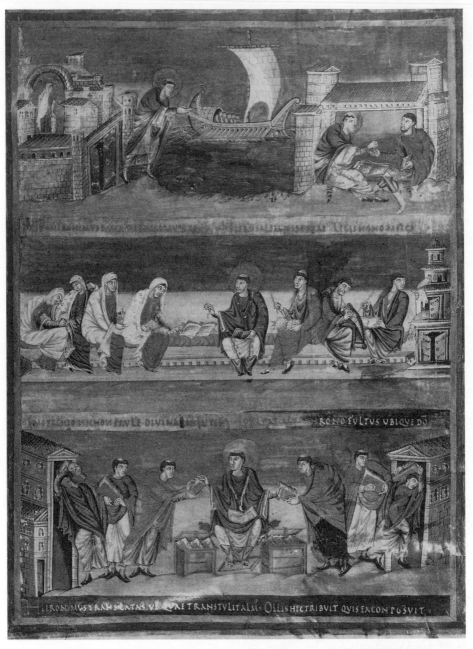

34 Scenes from the life of St. Jerome. Vivian Bible. Tours, c. 845. Paris, Bibliothèque nationale, ms. lat. 1, fol. 3v. Photo: Cliché Bibliothèque nationale de France, Paris

narrative such as a comic book. At the left, Jerome prepares to board a boat to leave Rome and travel to Jerusalem to learn Hebrew. In the right-hand scene, Jerome offers coins to his Hebrew teacher. The saint thus appears twice in what seems to be a single pictorial space. This kind of depiction, surprising to us, was very common in the early Middle Ages and apparently caused little confusion for medieval viewers. The artist has emphasized that Jerome is shown twice by representing the saint with the same facial features, tonsured head, and golden halo. Throughout the page this halo is unique to Jerome and allows the viewer to identify him immediately.

The second register has only a single scene. Jerome, in the center, explains his translation of the Bible to two holy women, Paula and her daughter Eustochium. Books and writing are very much the subject of this image. Both Jerome and the foremost of the holy women have books on their lap, and a book lies open between them. The secretary behind the saint takes dictation with a stylus on a wax tablet, while in back of this man two scribes write, one on a scroll, the other in a book. (This last is a startlingly accurate historical detail; it was precisely in the fourth century, the era depicted in the miniature, that the codex, the modern form of the book, replaced the ancient scroll.) At the far left side, a female scribe also writes on a roll. The educational reforms that were part of the Carolingian renaissance required accurate texts; this engendered a deep interest in knowing how a particular text came to be, an interest manifest in the frontispiece to the Vivian Bible. There was no similar Carolingian concern with the origin of images, a sign of the relative status of word and image in the ninth century.

The miniature's third register, like the first two, is also concerned with the production and propagation of the Word. Jerome, again enthroned in the center, takes copies of his translation of the Bible from chests at either side of him and distributes them to tonsured monks, who bring the books into buildings probably meant to represent the churches of Christendom.

This frontispiece illustrates well the strengths and weaknesses of pictorial narrative. On the positive side is the artist's ability to use a variety of instantly identifiable signs to indicate the most important figures in the story. Jerome's halo and his central position in the sec-

ond and third registers immediately tell the viewer that the saint is the focal point. The repetition also indicates Jerome's prominence. But pictorial narrative has its limits. Most important is the inability of pictures to make the general propositions that are crucial to narrative; without text, pictures are unable to tell complex stories successfully. In the Jerome frontispiece, without the tituli beneath the miniatures or my extended exegesis in the past few paragraphs, this miniature would not be able to speak. Without text it would be impossible to know that the holy women are Paula and Eustochium, or that the man with Jerome in the upper right-hand scene is his Hebrew teacher. Narrative pictures can stand in for and expand upon books, but they cannot make those books obsolete.

If Gregory the Great were right and pictures were simply ersatz books, they would not be very compelling. It is unlikely that we would be interested in studying the art of the early Middle Ages if it simply duplicated what was in early medieval texts. In the word-dominated Middle Ages, when revealed truth came in the form of a text, many pictures *were* trying to duplicate writing. But not all early medieval pictures are simple narratives. There are also more complex, often nonnarrative images that convey information that texts cannot in ways that are purely visual. Such images, the subject of the rest of this chapter, show that the creation of meaning in early medieval art was a complex process, one that Gregory the Great's dictum was insufficient to explain fully. Early medieval images could be books of the illiterate, but they could be much more as well.

The Jerome frontispiece from the Vivian Bible contains some nontextual elements. For example, Jerome's halo and his central position instantly indicate his importance. To express verbally the meaning conveyed by these signs would take many words, which would take a lot of time to read or hear; the instantaneous impact of the visual would be lost. The range and degree of subtlety of visual signs are infinite. Centrality and haloes are relatively crude, but more nuanced cues are also present in the Vivian Bible frontispiece. In the bottom zone, Jerome is shown seated not on a bench, as he is in the second register, but on a special kind of chair, a folding stool with crossed legs and lions' heads at the ends of its arms. This stool, known as a *sella curulis*, was part of the equipment of early medieval rulers and

judges. Through this pictorial detail Jerome is identified as a lawgiver, with his translation of the Bible being understood as the law.[1]

Visual elements introduced into a narrative illustration could convey meaning, but the artists of the early Middle Ages also had a whole array of purely nonnarrative tactics to produce meaning. One of the most important of these was typology. Typology is a peculiarly Christian way of reading the Bible; it understands the Old Testament as prefiguring the New. This interpretive technique was first used by Christ himself, who said, "For as Jonah was in the whale's belly three days and three nights, so shall the Son of man be in the heart of the earth three days and three nights" (Matt. 12:40); Christ understood an Old Testament event, the prophet Jonah's three-day stay in the whale, as a prefiguration or type of his own burial and resurrection after three days. With this divine authority, typology became a preferred Christian method for reading scripture.

The *Te igitur* page of the Drogo Sacramentary is an example of typology in early medieval art [18]. The *Te igitur* prayer opens the part of the mass devoted to the Eucharist, the transformation of bread and wine into Christ's body and blood. The mass was instituted by Christ at the Last Supper, when he told the disciples to eat bread and drink wine in memory of him. But in the Drogo Sacramentary, the *Te igitur* page is not decorated with scenes of the Last Supper, nor does it depict a priest performing the mass. Rather, a series of prefigurations of the mass from the Old Testament book of Genesis were chosen for the initial. In the center of the crossbar is Melchizedek, a priest-king who brought bread and wine to Abraham (Gen. 14:18). In the New Testament Epistle to the Hebrews, the shadowy figure of Melchizedek was interpreted as a type of Christ himself, with Melchizedek's gift of bread and wine seen to prefigure the mass; hence his depiction in the Drogo Sacramentary. Because Christians understand Christ's death on the cross, which is commemorated in the mass, as his self-sacrifice, two other Old Testament sacrificers, Abel with a lamb and Abraham with a ram, decorate the extremities of the *T*'s crossbar.

Typology has deep implications for the early medieval understanding of history because it expresses a peculiarly Christian notion of time. Although most of the Old Testament is a chronological narra-

tive, medieval Christians "misread" the text as a series of unconnected events, interesting not in their own right but taking shape only in reference to the master narrative of Christ's life. In the *Te igitur* page of the Drogo Sacramentary, three discrete moments from the historical narrative of Genesis are ripped out of their context and reassembled because they are all understood as referring to a Christian event, the mass. Typological time is thus very different from the modern, linear notion of time.

In this way, among others, typological time is like another important medieval Christian temporal scheme, liturgical time. The liturgical calendar was linear, progressing through the year, and also cyclical, repeating itself exactly each year. Thus, Christmas annually falls on the same date, and even movable feasts (those without a fixed date, such as Easter) recur according to an established pattern. But liturgical time stretches beyond the linear and the cyclical; the mass, with its literal reenactment of Christ's original sacrifice, implies a much more unusual conception of time as a single, seminal event from a distant past is daily made fully present. When the Eucharist is literally transformed into Christ's body and blood, the fabric of time is ripped apart; a European man or woman of the tenth century partaking of the bread and wine of the mass was suddenly transported back to the Last Supper and Jerusalem in the early years of the first century. Like typology, the liturgy thus made the events and people of long ago immediate and present. These temporal schemes have important implications for our understanding of early medieval art, both narrative and nonnarrative. They also indicate how radically different early medieval modes of thought are from our own, reinforcing for us that period's strangeness.

Typology was not a fixed system. A few correspondences had scriptural authority; these included Jonah in the whale as a type of Christ's resurrection or Melchizedek's offerings as a prefiguration of the mass. Some other pairs, such as Abraham's willingness to sacrifice his son Isaac as a type of God's willingness to sacrifice his son, Jesus, were established early and authoritatively.

But many other typologies were more fluid. An unusual example is found in an interesting pair of ivories that introduces one of the more remarkable artistic personalities of the early Middle Ages and shows

some of the richness of the early medieval understanding of the word [35]. Now two separate panels, these ivories were originally hinged to make a diptych, probably for liturgical use. Because of their unusual style, the carvings are difficult to locate art historically; scholars differ about their place of origin and date. Some favor Trier around 990, and others argue for Echternach in the middle of the eleventh century. One of the panels shows Moses on Mt. Sinai receiving the tablets of the Law from the hand of God. The other represents the moment after Christ's death and resurrection when the apostle Thomas, not believing that Jesus had truly risen, was invited to place his finger in Christ's wounds to verify their existence. Christ, identifiable by his distinctive cross-halo, pulls back his cloak to allow Thomas access to the wound in his side. Thomas is shown in an extremely complex and awkward posture, almost as if he were climbing up Christ's body. Although we see him from behind, his head is thrust so far back that his eyes, nose, and mouth are all clearly visible. Above the arch are inscribed Christ's words to Thomas: "Put in thy finger hither and be not [faithless, but believing]" (John 20:27).

The ivories were meant to be seen as a pair. This is confirmed by a series of rather eccentric visual and thematic links. One of the most curious is that the hand of God holding the tablets of the Law is framed by the same cross-halo as that behind Jesus' head. The cross-nimbus is a distinctive symbol of Christ (the cross refers to the Crucifixion), who, of course, was not present on Sinai.[2] Also odd is the emphasis on fingers in both ivories. The Old Testament tells us that the tablets of the Law were "written with the finger of God" (and God's fingers are clearly shown to us by the artist), while Thomas's use of his fingers to palpitate Christ's wound is both depicted in the ivory and explicitly noted in the inscription. Such details indicate clearly that the two ivories form a pair. But what intellectual principle links them? What is meant by the juxtaposition of Moses, receiving God's Law directly from God, with Thomas, who did not trust his eyes or his ears (or his faith) but, rather, needed to verify his doubt by physical touching? Thomas's doubt is usually seen in a negative light, but under the rules of typology the New Testament scene should be superior to the Old Testament one, since Christians believe that the New Testament surpassed the Old.

35 *Diptych with Moses and Thomas. Trier, c. 990 or Echternach, c. 1050. Berlin,*
 Staatliche Museen. Photo: Staatliche Museen zu Berlin—Preussischer Kulturbesitz
 Skulpturensammlung

A full solution to this problem would go far beyond the bounds of this book. A partial answer is to be found in the Christian understanding of the Old Testament. Early on, Christians were faced with a crucial question: Did the precepts of the Jewish Law apply to them, or had Christ's coming abrogated the Law? The most influential answer was given by the apostle Paul, himself a converted Jew, who believed that Christ had transcended the Law, that it no longer applied to Christians. Paul concocted a whole series of metaphors to explain his position, the most famous of which contrasted the Jewish letter with the Christian spirit. As he wrote to the gentiles in the Greek city of Corinth:

> You are the epistle of Christ, ministered by us, and written not with ink, but with the Spirit of the living God; not in tablets of stone, but in the fleshly tablets of the heart. For the letter killeth, but the spirit giveth life. (2 Cor. 3:3,6; slightly adapted)

Later, Paul goes on to call the Mosaic Law "the ministration of death, engraven with letters upon stones" (2 Cor. 3:7).

For Christians, the written word of the Old Testament Law is insufficient; indeed, it leads to death, whereas the spirit gives life. This letter/spirit dichotomy is the subject of these ivories; the Old Testament letter received by Moses is contrasted with the Christian spirit. But the example of spirit chosen here, doubting Thomas, is interesting because he is fallible. Thomas, refusing to believe the words of Christ or the evidence of his eyes, needed to manipulate Christ's wounds physically before he believed. The typological program of this ivory diptych is an important qualification to my argument about the power of the word in the early Middle Ages. The word was not always privileged, precisely because it could be like the Old Testament, a dead letter. But the story of Thomas also called into question the visual evidence of the eyes. For Thomas, the truth needed to be not only visual but tangible. Is it coincidence that this pair of subjects contrasting the verbal with the tactile was represented not in the flat paint of a manuscript but in the deeply carved surfaces of ivory? Or that this diptych was probably used in the mass, the event through which Christ's disembodied, verbal message in the gospels becomes

tangible and real through the transformation of the Eucharist, the celebration of the word become flesh?

Most examples of early medieval visual typology are not so ambiguous. In the Vivian Bible, the gospels' frontispiece depicts Christ enthroned in majesty, as he will be at the end of time, after the Last Judgment [36]. Christ sits on the globe of the world; the mandorla, a full-body halo, indicates his divinity. Just outside the mandorla are the symbols of the four evangelists. The evangelists themselves, writing their gospels, are depicted in the corners of the miniature. At the angles of the diamond-shaped frame surrounding Christ are the four most important Old Testament prophets: Ezekiel, Isaiah, Daniel, and Jeremiah. This miniature is rich with typological symbolism, both visual and verbal, and it provides a fine example of how complex theological ideas were expressed pictorially in the early Middle Ages. One such idea is the unity of the four gospels. Christians asked why there were four distinct gospels, all telling the same story; although the gospels are quite consistent, the inevitable discrepancies are embarrassing and problematic because each evangelist's account is believed to be authoritative. The Vivian Bible's miniature of Christ in majesty firmly insists on the unity of the evangelists and, by extension, their texts. There is a symbol of an evangelist at Christ's head, foot, and each hand, and a portrait of an evangelist in each corner of the miniature. No gospel writer is given special weight or prominence.

The Vivian Bible contains the full text of the Old and New Testaments under a single set of covers. Although one-volume Bibles are familiar to us, they were rare in the early Middle Ages. The gospel book or the gospel lectionary was used in the mass, so most Christians did not need a full Bible. And technical issues made such large books extremely difficult to produce. The very fact of the Vivian Bible's existence, then, signals an unusual concern for the unity not only of the four gospels but also of the two Testaments. This unity is signaled in the gospels' frontispiece by the presence of the major prophets along with the evangelists. One of the prophets' favorite subjects was the coming of the Messiah, whom Christians identify as Christ. The prophets, whose writings end the Old Testament, pay homage to Christ, whose story is told in the gospels, the first books of

36 *Christ in majesty. Vivian Bible. Tours, c. 845 Paris, Bibliothèque nationale, ms.
lat. 1, fol. 329v. Photo: Cliché Bibliothèque nationale de France, Paris*

the New; the Christ in majesty page is a hinge between the two testaments.

Although Christians believe in the unity of the Bible, they also believe in the superiority of the New Testament and law to the Old. This, too, is indicated in the miniature: The prophets hold scrolls, a type of book that fell out of favor in late antiquity, while all of the New Testament figures (the evangelists, their symbols, and Christ) hold codices, the modern-day form of the book. Since the Vivian Bible is itself a codex, this image reinforces the modernity and Christianity of the very book the reader would be using when he looked at it.

Typology is one of the most interesting and unusual aspects of early medieval art because its pictorial potential is very different from its textual possibilities. Verbal typology typically uses the simile. Christ says that "as" Jonah was in the belly of the whale for three days, so would he himself be in the earth for three days after his Crucifixion; Christ's act is similar to Jonah's, not identical to it. Verbal typology typically avoids metaphor, the more direct form of comparison: Christ is like Jonah, but he is not Jonah. Pictures, however, have great difficulty in distinguishing between simile and metaphor, typically dropping the "like" or "as" of the simile and simply rendering one thing as another.

A fine example of this directness of pictorial typology is found elsewhere in the Vivian Bible, in the miniature before the Old Testament book of Psalms depicting King David, the author of the Psalms, holding his harp [37]. Like the portraits of evangelists in gospel books, this is a familiar type of early medieval image: the portrait of an author as a frontispiece to his text. David is in a large, almond-shaped frame, surrounded by four seated musicians and two standing armed bodyguards. In the corners of the miniature, female figures hold palm branches; inscriptions identify them as the cardinal virtues: prudence, justice, strength, and temperance. There are several parallels between this miniature and that of Christ in majesty later in the Bible. In particular, the close facial resemblance between Christ and David and the four seated assistants in both miniatures establish a visual association, one that makes theological sense, for Christ was a lineal descendant of the Old Testament king (indeed, this blood relationship is one

37 *David composing the Psalms. Vivian Bible. Tours, c. 845. Paris, Bibliothèque nationale,
ms. lat. 1, fol. 215v. Photo: Cliché Bibliothèque nationale de France, Paris*

of the things that indicated that Christ was the Messiah). The visual tie is more immediate, more direct than any verbal connection; David is not just like Christ, he is another Christ.

This typological series in the Vivian Bible extends beyond David and Christ and takes us up to the making of the manuscript itself. The miniature on the Bible's last page shows a group of monks from the monastery at Tours presenting the Bible to Charles the Bald [38]. This image relates the Carolingian king Charles to the Old Testament king David. Both rulers are flanked by armed guards, and in both miniatures female personifications bearing palms appear in the upper corners. The two kings also have identical crowns and, most strikingly, identical facial features. It is not surprising that Charles and David are visually linked, for the two were also associated verbally: Many Carolingian rulers, starting with Charles's grandfather Charlemagne, had tried to connect themselves to David; in the Vivian Bible itself several poems address Charles as "David." In this case, the pictorial message repeats and strengthens the verbal message.

Of course, if Charles the Bald in the Vivian Bible looks like David, he also looks like Christ. Is it possible that Charles is meant to be associated with God? The very question seems blasphemous. It is one thing for the earthly Carolingian ruler to relate himself to the earthly Old Testament king. It seems quite another for Charles to connect himself to the divine King of Kings. If this typology is present in the Vivian Bible it is understated, so we cannot be sure if Charles really was meant to be seen as another Christ. But the king/Christ analogy is explicit in another early medieval manuscript, a gospel book made around 1000 for the Ottonian king Otto III [39].

Most luxury Carolingian and Ottonian gospel books opened with a miniature of Christ in majesty and, at first glance, this miniature seems to fit the expected pattern. A figure is enthroned in the heavens, crowned by God and flanked by the symbols of the evangelists. A mandorla surrounds the throne, and two crowned figures carrying flags bow their heads in fealty. The throne itself is supported by a female personification, probably of the earth, and at the bottom of the miniature are two armed guards and two tonsured clerics. Amazingly, all indications to the contrary, this figure is not Christ but Otto III (he is named in an inscription on the facing page). Although it is not sur-

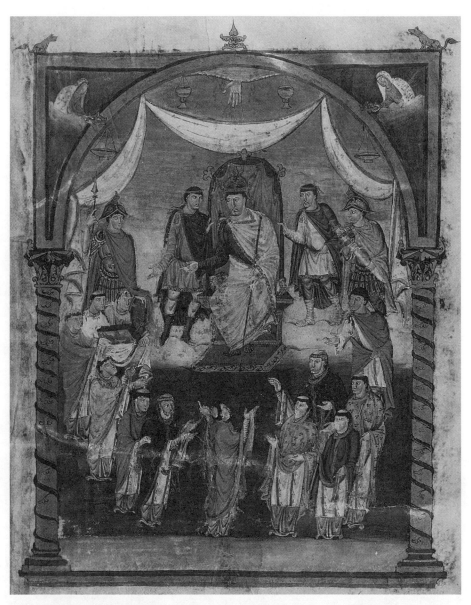

*38 Bible presented to Charles the Bald. Vivian Bible. Tours, c. 845. Paris,
Bibliothèque nationale, ms. lat. 1, fol. 423. Photo: Cliché Bibliothèque nationale de
France, Paris*

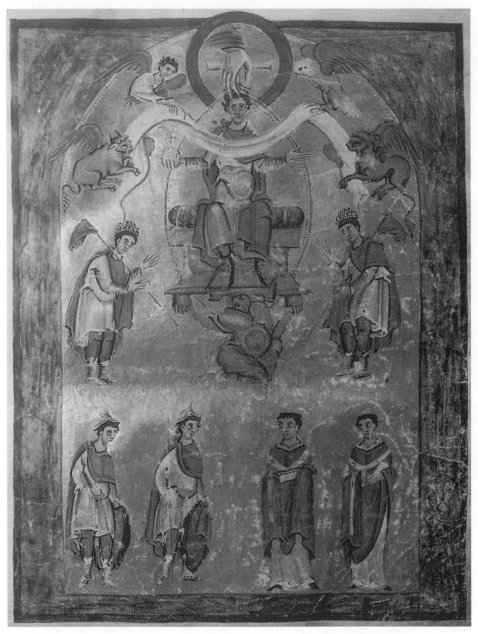

39 *Otto III enthroned in majesty. Gospels of Otto III. Reichenau, c. 996. Aachen,
Domschatzkammer, fol. 16. Photo: Domkapitel Aachen (Foto Münchow)*

prising to see earthly powers, such as the crowned men with pennants, the armed guards, or the clerics, pay the Ottonian monarch obeisance, since medieval rulers were thought to be both archpriest and archking, it is unique to see a human king surrounded by the symbols of the evangelists, who otherwise accompany only the divine ruler, Christ. It is even more surprising that this miniature of Otto in majesty replaces the expected image of Christ in majesty, which is nowhere to be found in the manuscript. Otto is depicted here in Christ's place, not simply as Christ-like. Visual typology again expresses directly through metaphor (Otto *is* Christ) what verbal typology, which works through simile (Otto is *like* Christ), can say only indirectly.

Even though visual typology sometimes surpassed verbal typology, typology originated as a tool for interpreting text, and it remained a basically verbal construct. But early medieval images also conveyed meaning in ways that were essentially independent of verbal models. These show that Gregory's association of word and image, however powerful and influential it may have been, is insufficient as an account of early medieval art. One way in which early medieval artists conveyed meaning in nonverbal ways was through copying other works of art. A series of significant copies spans this book chronologically and geographically; this series provides a fine example of how copying could make meaning in the early Middle Ages.

In the middle of the fifth century, the entrance facade of Old St. Peter's in Rome was decorated with a huge mosaic depicting the adoration of the Lamb by the twenty-four elders, an event described in the New Testament book of Revelation. This mosaic was destroyed with the rest of the church in the sixteenth century, but its appearance is preserved in an eleventh-century manuscript, in a drawing of Gregory the Great's burial in front of St. Peter's [40]. The Roman basilica's facade is in the background. The Lamb of God is in a circle at the point of the gable, adored by the four living creatures (the source for the symbols of the evangelists); below, in the window zone, six groups of four crowned elders, each elder with a vessel in his hand, pay the Lamb homage.

Around 800, this facade (or perhaps another Roman image derived from it) was the model for a depiction of the adoration of the Lamb in

Anno dnice incarnationis sexcentesimo .v. beatus gregorius. post quam sede Romane & aplice eccle tredeci annos . menses . vi . & dies .x . gloriosissime rexit defunctus est . atq; ad etna regni celestis sede ins latus est ;

40 *Burial of Gregory the Great with facade of Old St. Peter's*. Life of St. Gregory.
Farfa (?), last quarter of the eleventh century. Eton, Eton College Library, ms.
124, fol. 122. Photo: Reproduced by permission of the Provost and Fellows of Eton
College

a gospel book made for Charlemagne and known as the Soissons Gospels (after the French monastery to which it was given by Charlemagne's son; [41]). In the Carolingian manuscript, as at Old St. Peter's, the Lamb of God, in a roundel above the row of four living creatures, is adored by the twenty-four elders, here divided into only two groups. The bulk of the miniature, the bottom two-thirds, represents the heavenly Jerusalem, the subject of the book of Revelation. Charlemagne's interest in claiming the legacy of Rome was discussed in Chapter 2. In the Aachen chapel the evocation of Rome was literal, as pieces from the imperial city were brought north to Charlemagne's capital. In this gospel book made at Aachen the invocation was virtual: Rome was copied rather than literally incorporated. But the programmatic intent was the same.

Art historians studying an illuminated manuscript try to understand the relationship of the book's text to its images. This miniature in the Soissons Gospels is an anomaly, since Revelation, where the adoration of the Lamb is described, is not a text found in a gospel book. Although detailed scholarly study discovered in the manuscript a preface to the gospels that discusses the adoration, the miniature is still exceptional.[3] Indeed, the only other medieval gospel book known to contain this scene is one mentioned in Chapter 3, the *Codex aureus* made for Charlemagne's grandson Charles the Bald. Do the Soissons Gospels lie behind the adoration miniature in the *Codex aureus* [43]? The answer is a resounding yes. Indeed, the *Codex aureus* is shot through with borrowings from Charles the Bald's namesake, Charles the Great. In the Soissons Gospels, Charlemagne evoked his favorite model, Rome; in the *Codex aureus*, his grandson tried to capture the power of his prestigious grandfather.

Particularly telling is the precise nature of the copying. The adoration miniature in the *Codex aureus* actually has two models from Charlemagne's Aachen. The idea of including the image came from the Soissons Gospels, but there is little visual resemblance between this model and its copy. The elders in the *Codex aureus* carry crowns; those in the Soissons Gospels carry musical instruments. The four living creatures of the earlier manuscript are lacking in the later one. For the iconographic details, Charles the Bald's artists turned to a different work of art made for Charlemagne, the mosaic on the ceiling of the

41 *Adoration of the Lamb of God. Soissons Gospels. Aachen, c. 800. Paris, Bibliothèque
 nationale, ms. lat. 8850, fol. 1v. Photo: Cliché Bibliothèque nationale de France, Paris*

palace chapel at Aachen. Although the present Aachen mosaic [33] is a late-nineteenth-century restoration, it is a reliable copy of the Carolingian original. To cite only one detail linking mosaic and manuscript, the Aachen elders and their counterparts in the *Codex aureus* hold crowns. In 870, when the *Codex aureus* was made, Charles had just captured Aachen from his brother Louis the German; the manuscript commemorated his brief control of the city, which he had long coveted. Charlemagne sat enthroned in the gallery at Aachen, looking up at the twenty-four elders adoring the Lamb. The younger Charles could not sit in the chapel, for he only controlled Aachen for a few months; but he could have himself represented like his grandfather, enthroned and looking at the adoration, as he did in a miniature from the *Codex aureus* that, with the adoration image, forms a two-page opening [42].

This series of copies that began in fifth-century Rome did not end with Charles the Bald. By the early eleventh century the *Codex aureus* had traveled from northern France, where it was made, to Regensburg in southeastern Germany, where it was used as a model for a sacramentary made for the Ottonian king Henry II [44]. The Ottonian artist was inspired not by the adoration of the Lamb but by the facing image of the enthroned Charles the Bald. He followed his Carolingian model quite closely, but had to make certain alterations. He converted the two angels hovering above the throne in the ninth-century miniature into women holding cornucopias, personifications of the regions of Henry's empire. The Carolingian miniature already had two such personifications, but the Ottonians conceived of their kingdom as divided into four parts, not two. Also, because the miniature of Henry II stands alone in the sacramentary rather than forming part of a two-page opening, Henry looks directly forward, instead of at the facing page, as Charles the Bald did. Henry's motives in copying the *Codex aureus* were straightforward. The Ottonians looked to their predecessors the Carolingians as models of royal and imperial power; through copying Charles's manuscript, Henry hoped to capture some of the Carolingians' prestige.

In the case of the *Codex aureus* and the Sacramentary of Henry II, the visual relationship between model and copy is extremely close; on the other hand, the *Codex aureus* barely resembles one of its models, the Soissons Gospels. This odd situation signals a fundamental difference

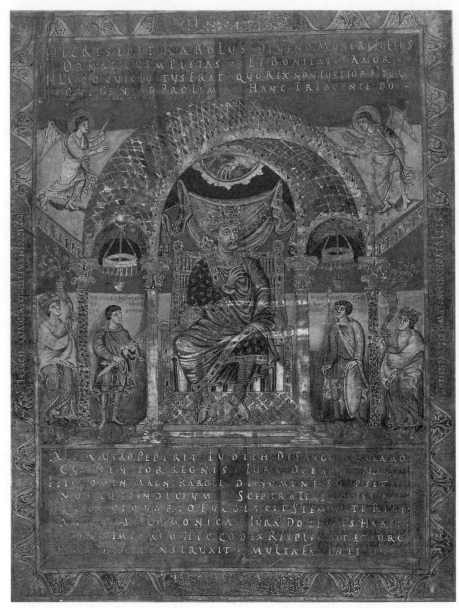

42 *Charles the Bald enthroned.* Codex aureus. *Court school of Charles the Bald,*
 c. 870. Munich, Bayerische Staatsbibliothek, Clm 14000, fol. 5v. Photo:
 Staatsbibliothek

43 *Adoration of the Lamb of God.* Codex aureus. *Court school of Charles the Bald,
c. 870. Munich, Bayerische Staatsbibliothek, Clm 14000, fol. 6. Photo:
Staatsbibliothek*

*44 Henry II enthroned. Sacramentary of Henry II. Regensburg, 1002–1014.
Munich, Bayerische Staatsbibliothek, Clm 4456, fol. 11v. Photo:
Staatsbibliothek*

between the modern conception of the copy, which is primarily visual,
and the medieval one, which was primarily conceptual.[4] Medieval
copies did not depend on complete visual similarity to their model, just
as medieval images did not require the artist to reproduce faithfully
what the eye saw. Copies in the Middle Ages typically resembled their
models in only one way. For example, the adoration miniature in the

Codex aureus derived its subject from the Soissons Gospels, but not its form. A modern copy, by contrast, resembles its model in all possible ways. Since medieval copying demanded only conceptual rather than visual likeness, in extreme cases model and copy might have no physical resemblance whatsoever, a fine example of the differences between the medieval and modern conceptions of the image and a sign of the need for historical inquiry to reconstruct the visual culture of the past.

Copying is closely related to spoliation, a phenomenon already examined; Charles the Bald could not despoil Aachen, so he copied it. Like copying, spoliation illustrates the gap between early medieval and contemporary attitudes toward images. Postmodernism has made it acceptable, even desirable, for visual artists to reuse past images; no longer must they strive to be entirely original, as they had to during modernism. Thanks to modern reproductive technologies, when contemporary artists reuse or rework images, they rework a copy rather than the original. Not so in the Middle Ages, when mechanical reproduction was unknown. Medieval craftsmen, like postmodern artists, recognized the visual charge that could come from appropriating a powerful or prestigious image, so they physically incorporated those images into the new work, destroying the reused image's original context. That destruction, anathema to us today as vandalism, was never chastised in the Middle Ages. The reason is telling: Art then was meant not to be beautiful but to perform some function. Images that had lost their function, for example pagan or outdated Christian ones, were worthless. These outmoded objects could be reanimated, but only if they were put into new settings. In the early Middle Ages, then, spoliation was a positive act rather than a negative one (contrast the connotation of the modern English word). It was also a way of making meaning without words.

A final way in which meaning was conveyed nonverbally in early medieval art was through significant pattern. In the Christ in majesty page of the Vivian Bible [36], the unusual frame around Jesus, diamond-shaped with circles at each of its angles, is not just a convenient pictorial device to bring the Old Testament prophets into close contact with Christ. It is also a pattern with its own meaning, used in early medieval diagrams and maps to represent the earth and thus appropriate for a depiction of Christ, the ruler of the world.[5] A more complex example of

45 *Frontispiece to Leviticus. San Paolo Bible. Reims, c. 875. Rome, Abbazia di San Paolo fuori le mura, fol. 32v. Photo: H. Kessler*

meaningful pattern is found in another Carolingian Bible made for Charles the Bald, the San Paolo Bible. This book takes its name from the church of San Paolo fuori le mura in Rome, where it is preserved. It almost certainly came there as a gift to thank the pope for crowning Charles emperor in 875. The church, sometimes known by its translated name, St. Paul's Outside the Walls, was built in the fourth century to honor the apostle Paul. The epithet "outside the walls" is telling: The church is outside Rome's walls because it is built over Paul's tomb. The apostle was buried outside the city because Roman law forbade burial inside (for the same reason, the church over Peter's tomb, the Vatican, is across the Tiber from the city of Rome). The shift from the pagan Roman abhorrence of the remains of the dead to the Christian cultivation of saints' relics is one of the most striking breaks between the classical and early medieval worlds.[6]

Most books in the San Paolo Bible are preceded by full-page miniatures. The frontispiece to Leviticus, which describes the Old Testament priesthood and its rituals, is divided into horizontal registers, as is common in the Carolingian Bibles [45]. But unlike the Jerome page in the Vivian Bible, which it outwardly resembles, the Leviticus frontispiece in the San Paolo Bible is not primarily composed of storytelling pictures. Although there are narrative elements (as in the third register from the top, which shows Moses establishing the priesthood among Aaron's sons, or the fourth, showing various animal sacrifices), the bulk of the miniature is nonnarrative. The top register represents the Old Testament tabernacle; the second shows the inside of the tabernacle, with the Ark of the Covenant resting on an altar table. In the third register, the two narrative scenes of Moses and Aaron are separated by a menorah.

As expected in a Christian manuscript, the Jewish priesthood and its ritual implements have been reinterpreted typologically: The tent of the tabernacle and the cloth of the altar on which the Ark sits have been decorated with crosses. It is surprising, however, that the typological interpretation extends not just to such details but to the entire structure of the miniature, which is in the shape of a cross. The second register, composed of the tabernacle's columns, the cherubim on the Ark, and the Ark itself, forms the crossbar; the cross's vertical element is composed of the Ark, altar, and menorah.[7] Although there is a textual basis for this iconography in the New Testament, where

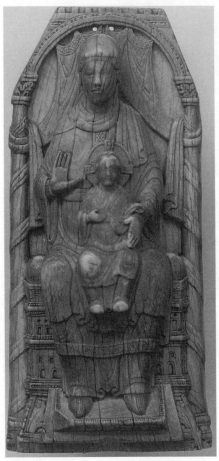

46 *Virgin and Child enthroned.*
Lorraine or middle Rhine, c. 1000.
Mainz, Landesmuseum. Photo:
Landesmuseum Mainz

Christ is called the high priest of "a greater and more perfect tabernacle not made by hand" (Heb. 9:11), this insertion of the central Christian sign into a depiction of the rituals of the Old Covenant is striking and unprecedented.

This chapter has complicated Gregory the Great's notion that pictures are the books of the illiterate. Early medieval images often functioned like books, but they also frequently tried to do things differently than texts. And some made no pretension at all to be like words; art historians call these iconic. A carved ivory of the Virgin enthroned with the Christ child on her lap is a fine example [46]. This small sculpture does not illustrate a biblical text, nor does it tell a story. It was made to focus the worshipper's attention on Mary and her son. Both figures are depicted as honored persons. Mary is enthroned, a ceremonial curtain behind her head. She is richly attired, as the border of her garments indicates, and completely frontal. Likewise frontal is Christ, whose divinity is marked by his cross-nimbus. Such images could not possibly be considered books for the illiterate. They are substitutes, true, but not for words; rather, this sculpture stands in for the real thing, the Virgin and her son. This surrogate quality of icons would cause considerable problems in the word-dominated Christian West, as Chapter 4 will show.

4

The Crisis of
Word and Image

◈⟶⟹◉⟸⟵◈

In accord with Gregory's letter, some early medieval images, such as the scenes from the life of Christ painted on the walls of churches throughout northern Europe, probably were used to educate the illiterate or the semi-literate. But as we saw in Chapter 2, Gregory's justification of images, even though it was often repeated, was irrelevant to many users of early medieval art, the literate clerical and secular elite. And as I argued in Chapter 3, early medieval images often did things that texts could not. This disjunction between the Gregorian theory of images as substitute books and the actual use and power of images brought about a crisis of word and image, a crisis with two contradictory outcomes: a renewed insistence by early medieval art theorists on the inferiority of the image to the word, resulting in new attempts by art makers to subjugate image to word; and a new theory and practice of images that attempted to separate them completely from the verbal realm. This chapter will examine both strategies.

The eighth and ninth centuries saw a remarkable debate in the Byzantine Empire about the status of the image. From the 720s until 787, and again in the first half of the ninth century, the Byzantine emperors supported iconoclasm, the destruction of images. Scholarly consensus has not been reached over iconoclasm's root causes, which were complex and extended far beyond concerns about image prac-

tice.[1] But that practice elicited considerable comment in both East and West. The debate centered around a tendency among viewers of images to confuse the representation for what was represented, a practice the iconoclasts believed was idolatrous.

Although the extremes of iconoclasm and its opposite, iconodulism, were almost exclusively Byzantine phenomena in the early Middle Ages, Eastern positions on images sometimes provoked reactions in Western Europe. In 787 a Byzantine church council reinstituted the cult of icons as official practice. Charlemagne's court prepared a detailed response, the so-called *Libri Carolini* ("Carolingian Books"; hereafter *LC*), by far the longest medieval discussion of images.[2] The *LC* applaud Gregory the Great's position that images should be neither destroyed nor adored, but they reject his justification of images as substitute books. They cite the pope's letter to Serenus approvingly (they could hardly do otherwise, for Gregory was one of the most important figures in the Western church), but they conspicuously omit the passage comparing pictures and books.[3] While paying Gregory lip service, the *LC* put the lie to his argument, for they are at great pains to argue the difference between the Bible's text, which is sanctioned by God, and images, which are not.

One of the most common words in the *LC* is "manufactured," used in its literal sense of "made by hand," to distinguish the creations of human artists from God's creations. The *LC* insist on distinguishing mundane works of art from truly sacred objects: the relics of saints; the cross, sanctified by Christ himself; and the Old Testament cult objects made at God's command. The *LC* rhetorically ask about the sacred nature of the materials used to make an icon like that of Christ from Mt. Sinai [1], painted in encaustic (wax-based paint) on panel:

> There is holiness in a painted image? Where was it before the image was made? Perhaps in the wood, which was taken from the forest, scraps of which were burned? Perhaps in the colors, which are usually made out of impure things? Or in the wax, which binds both colors and dirt?[4]

This sarcastic, often overheated tone, which carries on more or less unabated through the five hundred pages of the modern printed edition, suggests just how much was at stake in early medieval images.

The *LC*'s detailed exposition of a theory of images is unique in the early Middle Ages. They are of special art-historical importance because they were written by men in the same circle at Charlemagne's court as those who produced such exceptional works as the Aachen palace chapel and the Soissons Gospels. Indeed the *LC*'s author, Theodulf, bishop of Orléans, was himself a patron of art, and his patronage allows us to examine whether early medieval image practice can be connected with image theory.

In the first years of the ninth century Theodulf built a chapel at his villa at Germigny-des-Prés in central France. The building was heavily restored in the nineteenth century, but the most important part of the interior decoration survives, a mosaic in the eastern apse above the altar [47]. Its subject is extremely unusual. Early medieval apses typically represented Christ, the Virgin, or the saint to whom the church was dedicated, but at Germigny Theodulf depicted the Ark of the Covenant. The Ark is the golden box at lower center. Its top is decorated with the images of two cherubim, as described in Exodus. Above the Ark the hand of God perpetually sanctions the object made at his command. Two much larger haloed angels are shown flanking the Ark, the tips of their wings touching; these are the statues erected by Solomon when he installed the Ark in his Temple (1 Kings 6:23–28). Theodulf chose this unusual subject for the most prestigious work of art in his church because the Ark fits perfectly in his scheme of images. In the *LC*, Theodulf explained why the Ark was unlike any other object:

> It is completely absurd, indeed foolish, to try to equate images with the Ark of God's covenant, to assimilate that which is made by the Lord's express command to that made by the will of some craftsman or other. For one was made at the Lord's command, the other to serve the dictates of art; one by that holy man Moses, the other by some workman; one by the lawgiver, the other by a painter; one abounds with mysteries, the other with nothing but pigment.[5]

Although the Ark was a visually impressive object, its chief purpose was to shelter a text. And not just any text, but the very tablets of the Law written with God's finger, a text not just divinely inspired, like

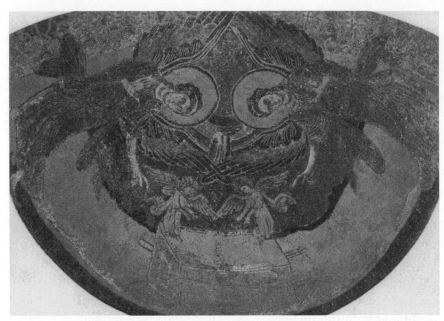

47 *Chapel of Theodulf, Germigny-des-Prés. Apse mosaic with Ark of the Covenant.*
 Early ninth century. Photo: Centrum Kunsthistorische Documentatie, Katholieke
 Universiteit Nijmegen

the New Testament, but also divinely authored. Yet at Germigny we
see not this text to surpass all texts but, rather, its richly ornamented
container. The mosaic thus broaches the word/image debate that so
dominated early medieval thinking about pictures, and it does so in a
brilliant way because of the Ark's charged place in that debate and the
closely related arguments about the justification of images. The Ark
sheltered the Ten Commandments, the second of which, strictly read,
forbade all representational art. Yet the Ark itself was decorated with
two cherubim, put there on God's command to Moses and made by a
human craftsman, Bezaleel. There was no more powerful refutation
of those who argued for a strict reading of the Second Command-
ment than these cherubim. Theodulf depicted them as well as the sec-
ond set of cherubim, the two that were placed around the Ark when it
was installed in the other great Old Testament example of divinely or-
dained images, Solomon's exceptionally richly decorated Temple.

Theodulf, who in the *LC* was intent on arguing against the Byzantine misuse of pictures, here emphasizes that certain images are divinely sanctioned and therefore proper. The brilliant crafting of this visual polemic is typical of Theodulf's aggressive thought.

The Carolingians were, however, in a bind. They lived in a world in which images, even if undesirable, were inevitable. The Mediterranean pictorial tradition, stretching back more than a millennium, was too important to the Carolingians to be ignored. Iconoclasm was not an option (the Carolingians agreed with Gregory that it was heretical), so they devised a number of schemes to control images, to channel their power in tolerable directions. Theodulf's solution, to mimic the divinely sanctioned images of the Old Testament, was one possibility. Thus, Carolingian and Ottonian goldsmiths copied the seven-branched candlestick and even the Ark itself. Written sources tell us of Carolingian reliquaries in the shape of the Ark;[6] these have been lost, but around the year 1000 Mathilda, abbess of the important monastery at Essen and the granddaughter of the Ottonian emperor Otto I, commissioned a huge bronze candelabrum in imitation of the one described in Exodus and made by Bezaleel, the craftsman of the Ark [48]. According to its inscription, "Abbess Mathilda ordered me to be made and consecrated to Christ." The Christian appropriation of the Old Testament symbols is blatant.

At precisely the same time that Mathilda was dedicating to Christ her copy of one of the divinely ordained works of art recorded in the Old Testament, a very different type of image was also being made at Essen, a statue of the Virgin and child composed of a wooden core covered with a sheet of gold [49]. The contrast with the candelabrum could hardly be greater, despite the fact that Mathilda may also have been patron of the golden statue. For unlike the candelabrum, this image of the Virgin did not have biblical sanction—far from it. When Moses was away receiving the Ten Commandments on Sinai, the Israelites became restless and began to doubt in God. Their doubts might have shown themselves in all sorts of ways, but they manifested themselves in an idol: the golden calf (Exod. 32). In their skepticism, the Israelites might have broken any of the commandments; they chose the second, the prohibition on idolatry. Such is the power of images. In late antiquity the association between sculpture and pagan

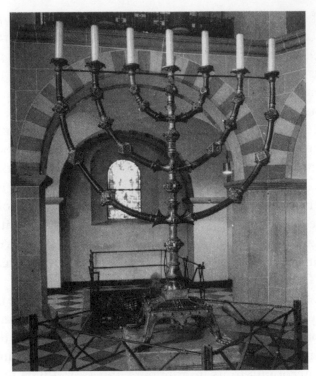

48 *Seven-branched candelabrum. Northwestern*
 Germany, 973–1011. Essen, Cathedral.
 Photo: Domschatzkammer, Essen

idols had been too strong to permit three-dimensional Christian im-
ages. Greco-Roman religion featured in-the-round cult statues of
gods and the emperor, and this pagan preference for statues probably
accounts for the early Christian abhorrence of them.

 We do not entirely understand why, at the very end of the Carolin-
gian period and into the tenth and eleventh centuries, the earlier
Christian prohibition on large-scale sculpture was lifted. But lifted it
was. There had always been depictions of Christ in three dimensions,
for the crucial theological fact of the incarnation, Christ's assumption
of human form, outweighed the fear of idolatry. But the chief subject
of the Essen sculpture is not the divine Christ but the fully human
Mary. Although the way the figures are rendered, especially the
otherworldly covering of gold and the statue's small scale (consider-

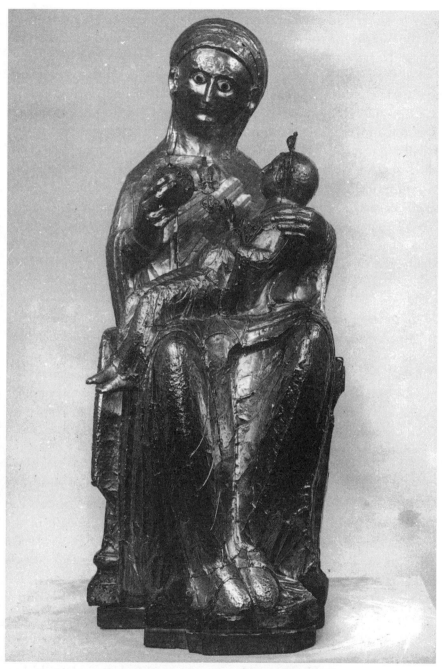

49 *Virgin and child. Essen (?), c. 980. Essen, Cathedral. Photo: Hans Sibbelee,*
Centrum Kunsthistorische Documentatie, Katholieke Universiteit Nijmegen

ably less than life size), prevent the viewer from mistaking this statue of the Virgin for the Virgin herself, the whiff of idolatry is not entirely absent.

But the Essen Madonna gets us ahead of our story; the fate of such statues in the early Middle Ages is the subject of the Conclusion. The Carolingian strategy of copying acceptable Old Testament images was too limiting because the handful of permitted objects was too small to perform all the roles art needed to perform in the early Middle Ages. A broader, more powerful tactic was also employed: the subjugation of the image to the word. This was not a Carolingian invention. As early as the fourth century the author of *The City of God* and *The Confessions*, St. Augustine (whose authority in the early medieval West was even greater than that of Gregory the Great), attempted to define the subordinate position of images to words:

> But just as, if we were to inspect a beautiful writing somewhere, it would not suffice for us to praise the hand of the writer, because he formed the letters even, equal, and elegant, if we did not also read the information he conveyed to us by those letters; so, he who merely inspects this deed may be delighted with its beauty to admire the doer, but he who understands does, as it were, read it. For a picture is looked at in a different way from that in which a writing is looked at. When thou hast seen a picture, to have seen and praised it is the whole thing; when thou seest a writing, this is not the whole, since thou art reminded also to read it.[7]

Augustine's position is highly reductive; he assumes that art is only beautiful and lacks further intellectual content, which he believes can be transmitted only through words. This was not the case in the fourth century, nor was it the case in the early Middle Ages, as I have tried to show. Augustine's text, however, is a sign of his lack of ease when confronted with the power of images. A similar uneasiness, felt by many Carolingians, motivated their insistent attempts to control images.

Carolingian writers were unanimous in agreeing with Augustine that the word (and even more so, the Word) was superior to the image. According to Hrabanus Maurus, abbot of Fulda and later bishop of Mainz:

The sign of writing is worth more than the form of an image and offers more beauty to the soul than the false picture with colours, which does not show the figures of things correctly. For script is the perfect and blessed norm of salvation and it is more important in all things and is more use to everyone. It is tasted more quickly, is more perfect in its meaning, and is more easily grasped by human senses. It serves ears, lips and eyes, while painting only offers some consolation to the eyes. It shows the truth by its form, its utterance, its meaning, and it is pleasant for a long time. Painting delights the gaze when it is new, but when it is old it is a burden, it vanishes fast and it is not a faithful transmitter of truth.[8]

This perceived superiority of word to image is made manifest in Carolingian art in a number of ways. One tactic made the Word the subject of art; thus, the Carolingians delighted in depicting how the Bible came to be written. The evangelists writing the Gospels, David composing the Psalms, and Jerome translating the Bible were all favored Carolingian subjects (cf. [34], [37]). Another more interesting and sophisticated device for representing the superiority of the verbal to the visual is found in a Carolingian manuscript of the Psalms made near Reims around 820 and known as the Utrecht Psalter. The Utrecht Psalter is exceptionally densely illustrated: Each of the 150 psalms is prefaced by a large miniature. The artists, rather than trying to express the content of a psalm in a single image, illustrated selected phrases from the psalm literally, juxtaposing these vignettes to form large, not entirely unified miniatures.

Characteristic is the illustration for the familiar Twenty-third Psalm [50]:

 1 The Lord is my shepherd; I shall not want.

 2 He maketh me to lie down in green pastures; he leadeth me beside the still waters.

 3 He restoreth my soul: he leadeth me in the paths of righteousness for his name's sake.

 4 Yea, though I walk through the valley of the shadow of death, I will fear no evil: for thou art with me; thy rod and thy staff they comfort me.

5 *Thou preparest a table before me in the presence of mine*
enemies: thou anointest my head with oil; my cup runneth
over.

6 *Surely goodness and mercy shall follow me all the days of my*
life: and I will dwell in the house of the Lord for ever.[9]

In the center of the miniature the psalmist, clad in long robes and
holding a cup, sits on the ground near a flowing stream, while an
angel hands him a long staff and anoints his head with liquid poured
from a horn. This central group combines elements from verses 2
(lying down; water); 4 (staff); and 5 (oil; cup). Directly in front of
the psalmist is the table of verse 5, set by the Lord in the presence of
the psalmist's enemies; the enemies themselves are at the lower
right, shooting arrows at the psalmist. Past the table are sheep,
calves, and goats; these are presumably a reference to verse 2's pas-
tures, but neither their number nor their variety is motivated by the
text. Behind the table is a small basilica with side aisles. Its peaked
roof is decorated with crosses, and an altar with a crown hanging
above it is visible in the doorway; this is the house of the Lord men-
tioned in verse 6.

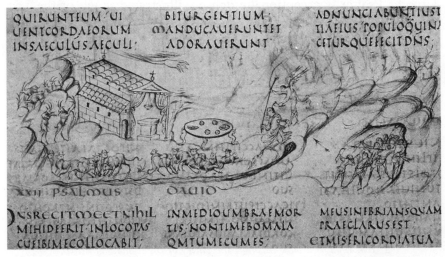

50 *Psalm 23. Utrecht Psalter. Reims, 816–835. Utrecht, Universiteitsbibliotheek,*
 Cod. 32, fol. 13. Photo: Universiteitsbiblotheek

The literal quality of the illustration is striking. The Carolingian illuminator has turned the amazingly rich poetic language of the psalm into the mundane; this is most apparent in the elegant table at the center of this miniature. There is also an emphasis on what is simple to represent; thus, the table before the enemies, the horn of oil, and the staff are all present because they are easily visualized and rendered. Missing, however, is the most striking image for the modern imagination: the valley of the shadow of death. The valley is indicated by the rocky outcroppings at either side of the miniature and by the stream in the middle, but the shadow of death proved too difficult even for the highly inventive artist of the Utrecht Psalter to picture.

Although it might seem as if the Utrecht Psalter, with a miniature prefacing each psalm, gives equal weight to text and image or even privileges the picture over the word, something very different is happening. Because of the exceptionally literal quality of the illustration, the Psalter's miniatures are dependent on the text; without it they are indecipherable, disintegrating into a bunch of apparently disparate motifs. Without previous knowledge of the Twenty-third Psalm, it would be impossible even to guess at what was going on in this miniature. Rather than books for the illiterate, the images in the Utrecht Psalter are literal pictorial renderings of the most canonical texts of the early Middle Ages. In this period monks chanted the Psalter weekly, a process that in short order would have imprinted every psalm on their minds. For such an audience, one that had fully internalized the Psalter, the images in the Utrecht manuscript would have been fascinating, almost like rebuses; the illiterate, on the other hand, would have found them simply baffling.

Given his earlier-cited denigration of the visual at the expense of the verbal, it may be surprising to learn that Hrabanus Maurus was not only an important patron of art but an artist himself. Like the Utrecht Psalter, however, Hrabanus's art is typically Carolingian in subjugating the image to the word. The Carolingians revived the classical and late antique genre known as *carmina figurata* ("figured poems"). These are verses composed of a grid of letters, within which subpoems are marked out to form pictorial images. Hrabanus was the unequaled master of this genre, producing a book of twenty-eight picture poems in praise of the cross. The opening page contains a

long poem about Christ within which, amazingly, ten independent shorter poems form a depiction of Christ on the cross without disturbing the sense of the major poem [51]. For example, the letters of Christ's halo read *"Rex regum et Dominus dominorum"* [King of kings and Lord of lords], while those representing his hair form the sentence *"Iste est rex iustitiae"* [This is the king of justice]. Hrabanus has taken considerable care to make each poem correspond to its pictorial role; thus, the verses on the loincloth read "This small cloth covers him who controls the stars." In a different way than in the Utrecht Psalter, but with the same result, the images in Hrabanus's book of poems on the cross are literally dependent on the word. If the letters are removed, the images disappear.

The subjugation of images to words is typically Carolingian. Carolingian art has been central to this book because Carolingian culture was central to the early Middle Ages. The reforms of Charlemagne and his successors brought about new and unprecedented cultural ideas, ideas that continued to have tremendous prestige and influence long after the dynasty itself had died out. The repeated insistence by the Carolingians that pictures are secondary to words is clear evidence that they recognized the potential power of images. To control that power, some members of the higher clergy, men such as Theodulf and Hrabanus, insisted publicly that it did not exist. But at least one Carolingian cleric was so worried about images that he took the route of Serenus of Marseilles and began to destroy them.

Early in the ninth century Claudius of Turin wrote a letter describing what happened when he became bishop of that northern Italian city:

> I found all the churches filled, in defiance of the precept of Truth, with those sluttish abominations—images. Since everyone was worshipping them, I undertook singlehanded to destroy them. Everyone thereupon opened his mouth to curse me, and had not God come to my aid, they would no doubt have swallowed me alive.[10]

Claudius went on to explain his position: "It is clearly enjoined that no representation should be made of anything in heaven, on earth, or under the earth; the commandment is to be understood not only of likenesses of other gods but also of heavenly creatures, and of those

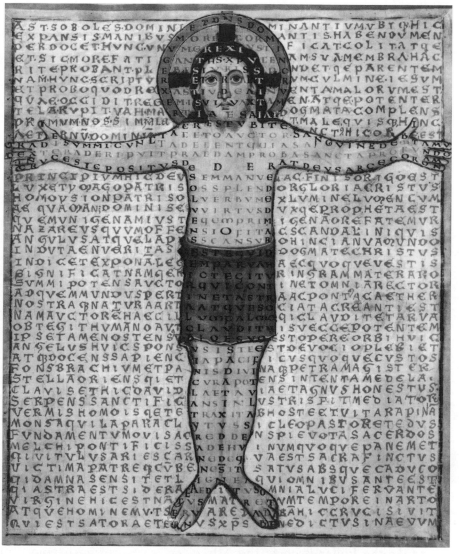

51 *Crucified Christ.* Liber de laudibus sanctae crucis. *Fulda, first quarter of ninth century. Vatican City, Biblioteca apostolica vaticana, MS Reg. lat. 124, fol. 8v. Photo:* © *Biblioteca Apostolica Vaticana*

things which human conceit contrives in honor of the Creator."
Claudius, against Christian tradition, read the Second Command-
ment strictly and literally. This led him, like Serenus, an earlier
bishop working near the Mediterranean, to destroy images, the ulti-
mate testimony to their power.

Elsewhere in early medieval Europe, defenders of images were not
entirely lacking, with the result that the Carolingian attempt to play
down the visual at the expense of the verbal did not go unchallenged.
The Fuller Brooch is a silver decorative pin for closing a cloak, made
in England toward the end of the ninth century [52]. The iconogra-
phy of the brooch is extremely unusual: personifications of the five
senses. In the center is Sight, distinguished by wide staring eyes. He
carries two cornucopias, the ancient symbol of abundance, probably
to show his importance. The dominance of sight is also apparent by
his central position and large size. Behind him (clockwise from upper
right) are the other four senses: Smell, a plant touching his nose and
his hands behind his back to avoid confusion with the other senses;
Touch, with one hand touching the other; Hearing, hand to his ear;
and Taste, hand in his mouth.

The Fuller Brooch is so unusual in both its iconography and superb
state of preservation that for a long time scholars considered it a
forgery. But the iconographic program privileging sight, the sense
most important to the artist, seems entirely right for a work of visual
art created in the ninth century, when the Carolingian glorification of
the verbal was at its height on the Continent. In contrast to the Car-
olingian orthodoxy, the Anglo-Saxon artist and his patron argue here
for the primacy of vision. As another Anglo-Saxon work, the Alfred
Jewel, shows, however, in England (as elsewhere in the early Middle
Ages) the visual was tied to the verbal.

Like the Fuller Brooch, the Alfred Jewel is an exquisite piece of
craftsmanship [53]. It consists of a gold mount in the form of a beast's
head with the Old English openwork inscription "Aelfred mec heht
gevvyrcan" [Alfred had me made]. The mount holds an enamel cov-
ered with a piece of rock crystal. The exceptional technical profi-
ciency of the gold work, the unusual technique of enamel, and the fact
that the rock crystal is a reused Roman piece all indicate that the Al-
fred Jewel is a very special object, although its figurative imagery is

52
Fuller Brooch.
Anglo-Saxon,
end of ninth
century. London,
British Museum.
Photo: The
British Museum

53
Alfred Jewel.
Anglo-Saxon, late
ninth century.
Oxford, Ashmolean
Museum.
Photo: Ashmolean
Museum, Oxford

difficult to decipher. The Jewel seems to depict a man holding two flowers or scepters. Although Christ was occasionally rendered in something like this pose in insular art, the absence of a halo argues strongly against identifying this figure as Jesus. The close resemblance in pose and attributes between this mysterious figure and the central personification on the Fuller Brooch, made in the same time and place, has led many to argue that Sight is also depicted on the Jewel.[11]

There is consensus that the Alfred of the inscription is Alfred the Great, the late-ninth-century ruler who styled himself as "king of the Angles and Saxons," although more sober-minded modern historians describe him simply as king of the rather small southwestern English region of Wessex from 871 to 899. As a youth Alfred had visited the court of Charles the Bald, and both his father and brother had been married to Charles's daughter, Judith. These Carolingian connections would have given Alfred access to works of art with the technical mastery and the intellectual complexity of the Alfred Jewel. Alfred, like his Carolingian relatives, combined artistic patronage with an interest in learning; indeed, in these respects he surpassed them. Charlemagne and his descendants had fostered literacy and letters as patrons; Alfred was both patron of and active participant in the ninth-century English intellectual rebirth. He translated the Psalms from Latin into Old English to make them more accessible to his subjects (in England, unlike in the Mediterranean countries, there was no continuous linguistic tradition linking Latin to the vernacular; hence the need for translations).

Alfred also translated one of Gregory the Great's books, the *Pastoral Care*. Alfred was drawn to this text because of Gregory's association with the conversion of the English and because the *Pastoral Care* concerned the proper way to form a Christian community, precisely what Alfred had in mind for his kingdom. In a preface to his translation Alfred described what he had done:

> I turned it [Gregory's Latin text] into English, and to every bishopric in my kingdom I will send one; and in each there is an *aestel* which is worth 50 *mancuses* [a substantial sum of gold] and in God's name I command that no man remove the *aestel* from the book.[12]

An *aestel* was probably a pointer. Alfred sent one with each copy of his translation to allow the reader to keep his place in the text without touching the page. The *aestel* thus functioned like a *yad*, the pointer still used by Jews when reading from the Torah so that they do not touch the holy words directly. The Alfred Jewel was probably the *aestel's* handle; the pointer itself, a rod of wood or perhaps ivory, would have fit into the open tube formed by the beast's mouth.

Sight is privileged on the Alfred Jewel, but it is a certain kind of sight, the sight needed to read words. The *aestel* directs the eye to the text. On the Alfred Jewel, reading is understood as a visual phenomenon. Although this agrees with the modern conception, it was unusual in the mixed oral/literate culture of the early Middle Ages, where texts were typically experienced at least as much with the ear as with the eye. In the early medieval period, reading was often done in groups, and silent reading was virtually unknown; even solitary readers would sound out the words while reading, making early medieval reading more aural than visual. This is one of the themes underlying Gregory's letter: Pictures, the books of the illiterate, are the visual corollary to the heard word. But it was precisely in early medieval England that silent reading developed, allowing reading to become the purely visual activity it is for us. This transformation in reading technology is witnessed on the Alfred Jewel.[13]

The so-called Talisman of Charlemagne [54] is like the Alfred Jewel in size, shape, and even technique, but it serves a very different function, one crucial to the development of early medieval art. The Talisman was probably made around 800 in a metalsmithing workshop, probably one associated with the Carolingian court, perhaps in Aachen itself. It is composed of two large sapphires set into a golden mount decorated with smaller gems in a variety of colors. It is said to have been found hanging around Charlemagne's neck when his Aachen tomb was opened in 1000 by Otto III, like the other Ottonians a great admirer of his imperial Carolingian predecessors. This account is not verifiable, but since the Talisman was at Aachen in the later Middle Ages, it is likely. Also likely is that this amulet was made to hang from the neck, since the small handles near the top are ideal for anchoring a chain.

Why would Charlemagne have wanted to hang the Talisman around his neck? The answer lies in what is between the two large

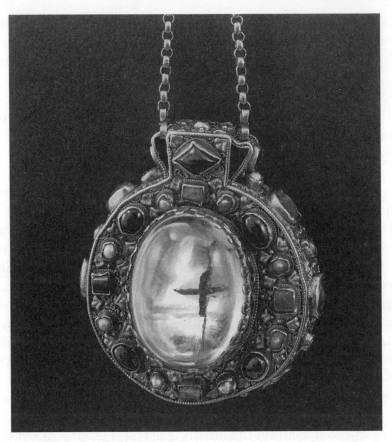

54 *Talisman of Charlemagne. France or Germany (Aachen?), c. 800.*
Reims, Cathedral Treasury. Photo: Joubert © CNMHS

sapphires. At present the Talisman houses one of the most precious of
all Christian relics, a small fragment from the cross on which Christ
was crucified. In the Middle Ages, however, the Talisman contained a
slightly less prestigious, but still impressive relic: a lock of the Virgin's
hair. Although the Carolingians denied the miraculous powers
granted to images by the Byzantines, they were willing to locate the
marvelous in relics of Christ, the Virgin, and the saints. At the same
time, then, that they were subjugating images to words, they were as-
cribing tremendous power to the visually unimpressive remains of the

saints. Charlemagne wanted the Talisman not for its aesthetic value as a work of art but to tap into the power of the relic. The medieval cult of relics is too large a subject to be examined in detail here, but its important implications for early medieval art require a brief outline.

Christ's incarnation was the crucial prerequisite for the cult of relics, just as it was for the Christian theory of images. Because Christ was fully human and had come to earth, he left material traces of his presence. Christ himself had ascended to heaven, but things he had touched remained behind, most notably the cross. The Virgin's body had also been taken up to heaven, but she too was remembered through so-called contact relics. And the entire bodies of Christ's human followers, the saints, were available. It was the cult of relics that guided Constantine's construction of a church over the tomb of Peter in Rome; the presence of the saint's bones made the hill of the Vatican a special place.

Although St. Peter's was built on the actual site of the saint's tomb, Christians quite soon realized that it was easier to bring the relic to the church than the church to the relic, and it became standard practice to move bodies to new, more convenient locations and to construct churches over them. These new churches were often in cities and towns themselves, rather than in the suburban sites where the martyrs' tombs had been because of the Roman prohibition on burial within the walls. A further development came with the spread of Christianity north of the Alps, where there had been relatively few saints and therefore were relatively few relics. Because of the shortage of holy men, saints were dismembered so that more than one church could possess their relics. And by the early Middle Ages it was customary for every altar to contain a relic, typically a small fragment of bone.

The cult of relics was primarily a Western European phenomenon. In the Byzantine East, icons of the saints were valued more highly than their relics, with the result that Byzantium developed a cult of images, the West a cult of relics. Byzantine image theory held that a picture of a saint was as authentic and powerful as his relics; for someone such as the literal-minded Theodulf, this was nonsense. For him the difference between relic and image was obvious: The relic was an

actual, physical part of a holy person; the image was simply an artist's fiction.[14]

Relics, extremely highly valued by medieval Christians, were believed capable of producing miracles. But they also posed a problem, because they are not much to look at. As early as the second century, a Christian author wrote that after a saint's martyrdom, "[W]e took up his bones, more precious than costly stones and more excellent than gold, and interred them in a decent place."[15] It is one thing to believe that relics are more valuable than gold and jewels, another to practice it; by the early Middle Ages, Christians had decided that the modest-seeming relics needed to be encased in precious vessels to prove their worth. A ninth-century saint's life describes a reliquary of St. Barnard, archbishop of Vienne in southern France:

> If anyone wishes to know the abundance of his deeds of virtue, he may take it as a sign that the box in which his most holy body is contained is well decorated with gold and silver from the abundance of gifts which the devoted hands of the faithful offered and is covered with skilled work. The gold crosses also attest to it, as do the candelabra decorated with gold and silver.[16]

This text draws a frankly causal connection between the rich outside decoration of the reliquary and its rich contents; the viewer can discern Barnard's moral virtue from the reliquary's ostentatious decoration. For this reason, ornate early medieval reliquaries like the Talisman of Charlemagne are common. Toward the end of the tenth century, Archbishop Egbert of Trier ordered a series of sumptuous reliquaries for his very important collection of relics, which included the sandal of Christ's disciple Andrew [55]. Egbert had access to the finest Ottonian artists (the miniature of Gregory composing a text with which this book began was also made for him), and the sandal reliquary is a masterpiece of goldsmithing. Most striking to a modern viewer is the reliquary's form: It is what German scholars call a "speaking reliquary," since its outer form tells the viewer what the hidden, inner contents are (in this case, Andrew's sandal).

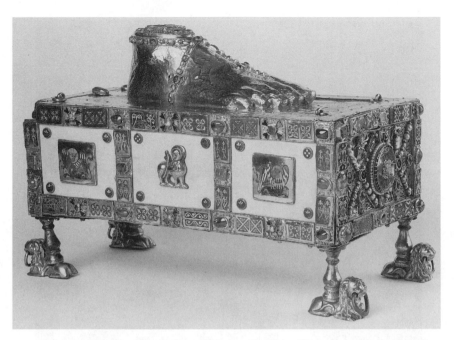

55 *Sandal reliquary of St. Andrew. Trier, c. 980. Trier, Domschatz. Photo: Amt für kirchliche Denkmalpflege, Trier*

Even more spectacular is the reliquary statue of St. Baudimus from the church of St. Nectaire in south-central France, probably made in the second half of the tenth century (the present head and hands are later medieval additions; [56]).[17] The Baudimus bust is a speaking reliquary; the relic inside has expressed itself as a portrait of the saint; the fragment of bone has clothed itself in a richly ornamented skin of gilt bronze, gems, and enamels. Baudimus is a saint about whom we know very little; his cult was strictly limited to the immediate region in which the statue was made. Although this reliquary appears to us rich and rare, it actually was part of what was, by early medieval standards, a relatively common class of images. Few statues from this group survive, their value as bullion and the anticlericalism of the French Revolution having taken a heavy toll, but a better-documented, even more spectacular survivor, the statue of St. Faith

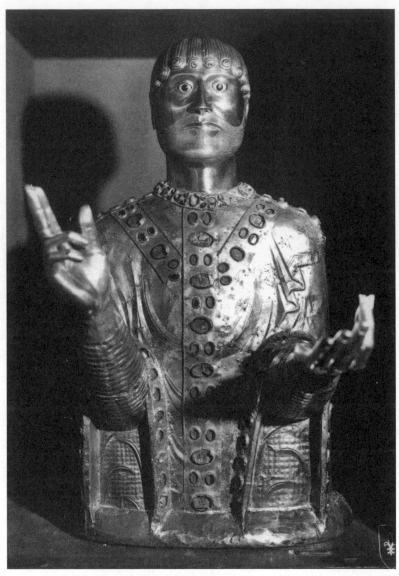

56 *Reliquary statue of St. Baudimus. South-central France, second half of the tenth century, with later additions. Church of Saint-Nectaire. Photo: Centrum Kunsthistorische Documentatie, Katholieke Universiteit Nijmegen*

from nearby Conques, is discussed in detail in the Conclusion ([Plate IV], [63]).

Speaking reliquaries can seem like bizarre curiosities, one of the oddities of the past. But they are of considerable significance because they are closely associated with the rebirth of three-dimensional images in the early medieval West. Many of the earliest sculptures in the round were also containers for relics, which were typically enclosed within them or inserted in holes at the back. Relics of the saints and the Virgin spoke and produced rich golden statues like that of Baudimus. (The medieval core of the Essen Virgin and Child does not survive, so we cannot be sure if it was a reliquary statue.) But relics alone cannot account for the rebirth of large-scale sculpture, for there were also early medieval statues of Christ, of whom few earthly relics remained; these make up a different but important class of images.

Between 969 and 976, when he was archbishop of the important city of Cologne on the Rhine in Germany, a certain Gero had made a life-size sculpture of Christ on the cross [57]. Firmly dated through its patron (a date recently confirmed by an examination of the tree rings in the wood from which the statue is carved), the Gero Cross garners a number of art-historical firsts. It is the earliest extant three-dimensional sculpture since antiquity and, as important, the first depiction of the Crucifixion in which Christ is shown dead. In the early Middle Ages, Christ was usually shown on the cross alive and at peace (cf. [19]). The emphasis was on his triumph over death rather than his redemptive suffering—on Christ as divine worker of miracles. As the Middle Ages progressed, however, attention shifted to the significance of Christ's humanity, and this change in theology and piety was manifested in the Gero Cross.

The cross is unusual in its naturalism; this stems not from the special skill of its artist but from his subject: the god-man, Christ. When early medieval artists rendered saints and kings, they typically represented not their human nature but their holy or royal aspects. Precisely because these people were mortals, however distinguished, it was necessary to insist on their superiority to their fellow humans. By contrast, Christ, whose divinity was unquestioned, did not require that the visual arts continually affirm his status; he could be depicted

57 *Gero Cross. Cologne, 969–976. Cologne, Cathedral. Photo: Rheinisches Bildarchiv Köln*

more humanely, as he is in the Gero Cross. Particularly impressive is the naturalistic rendering of death: Christ's entire body slumps, straining his thin legs to the breaking point, while his chin rests on his lifeless chest.

This new emphasis on Christ's humanity, along with the cult of relics, underlies the early medieval rebirth of three-dimensional sculpture. But whatever the theology or ritual practice justifying them, these life-size images made Christians vulnerable to the old charge of idolatry. Just that charge was made by an early-eleventh-century writer, Bernard of Angers, about southern-French statue reliquaries such as that of Baudimus (Bernard's text is discussed in detail in the Conclusion). And "idol" was the term used for a Christian image by a mid-tenth-century Spanish traveler through Europe, Ibrahim ibn Ya' qūb, who wrote in Arabic and was almost certainly a Muslim.[18] Since Islam interpreted the Second Commandment strictly and forbade images, Ibrahim was shocked when he came to the central German monastery at Fulda. His account is a fascinating document of a member of one culture encountering a foreign one:

> Fulda is a large city in the land of the Franks, built of stone. It is inhabited only by monks and no woman enters it, because their martyr ordained it so. The name of their martyr is Baugulf [a mistake for Boniface; Baugulf was a ninth-century abbot of Fulda].
>
> Fulda is a large church, held in high esteem by the Christians. I never saw, in all the Christian lands, a larger one or one richer in gold and silver. Most of its vessels, such as censers, chalices, pitchers, and plates, are of gold and silver. There is also there a silver idol in the form of their martyr, its face to the west. There is another idol of gold whose weight is 300 *ratl* [several hundred pounds]; it is attached at the back to a tall, wide tablet set with hyacinths and emeralds. He has his arms spread like someone crucified; it is the image of the Messiah—peace to him! There are also found there gold and silver crucifixes and reliquaries, all made of gold and silver, set with hyacinths.[19]

Ibrahim had no doubt that the images he saw at Fulda were idols. It is ironic that the depiction of Boniface, probably a reliquary statue,

was immediately identified as an idol, for Boniface, an English monk sent in the early eighth century to convert the pagans in the Low Countries and Germany, specialized in destroying idols. He cut down the holy oak tree at Geismar in Germany, one of the most public assertions by the Christians of the superiority of their religion. In 744 Boniface founded the monastery at Fulda as a kind of outpost in his missionary effort (his letter about the value of golden manuscripts for converting the heathen was cited in Chapter 1); ten years later he met a martyr's death at the hands of pagans. And two centuries after his martyrdom, a huge, rich image of the destroyer of pagan idols was taken for a Christian idol by a Muslim traveler to Germany.

The Gero Cross and these statue-reliquaries signal a new function for art in the early Middle Ages. Works in three dimensions rather than two, they were part of a widespread crisis of the image in the West. But at least most of these presumptive idols had the power of the Christian relic or the theology of the incarnation to justify them. What about other post-Carolingian images? The Carolingian attempt to check the power of the image was doomed to failure because it attempted to control verbally objects that worked visually. This failure required the Ottonians, the successors to the Carolingians, to develop a new theory of images, one independent of Gregory's idea that pictures were substitutes for books.

Influenced by Neoplatonism, some people in the late tenth century came to believe that pictures could lead the mind to God, with or without the presence of relics. The Neoplatonists held that there was an important relationship between the visible things of our world and the invisible, divine things of heaven. These ideas are familiar in the history of art from later medieval writings, particularly those of Suger, abbot of Saint-Denis, who in the twelfth century wrote that "[t]he dull mind rises to truth through that which is material."[20] Suger's famous belief that material things could lead the mind to God's immaterial world helped to introduce the Gothic style to twelfth-century France. Much less well known is that it was presaged 150 years earlier in Germany, also with important consequences for art history.

Around 1000 a richly illustrated gospel book was made in Cologne for Hitda, abbess of a nearby convent. (Hitda may well have been a

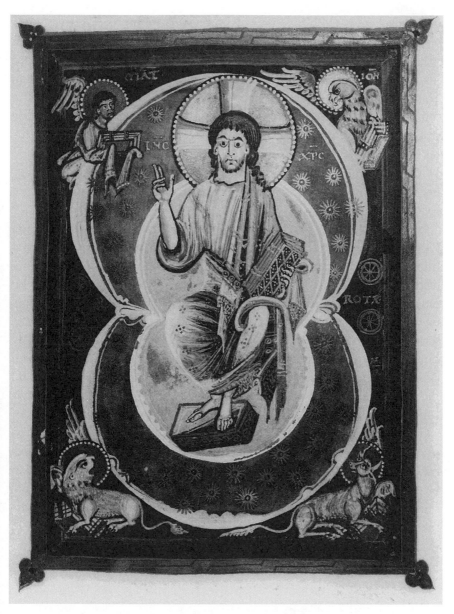

58 *Christ in majesty. Hitda Gospels. Cologne, c. 1000. Darmstadt, Hessische Landes–*
 und Hochschulbibliothek, Hs. 1640, fol. 7. Photo: Landes– und Hochschulbibliothek

close relative of Cologne's archbishop, Gero.) The manuscript opens with a relatively simple version of the familiar image of Christ in majesty [58]. Christ is enthroned on the globe of the world, a book in his hand, and is surrounded by the symbols of the four evangelists. Some verses on the preceding page form a two-page opening with the miniature and claim that "[t]his visible image depicts that invisible truth whose splendor penetrates the world."[21] According to this titulus, the picture, visible to all, depicts the hidden truth that all seek. With this simple but groundbreaking justification of pictures, Gregory the Great has been turned on his head: the image is now the Bible for the literate.

How did these remarkable verses come to appear in the Hitda Gospels? The Ottonians had some connections with the Greek East (most notably through the marriage of Otto II to a Byzantine princess), where the theology of images was close to that articulated in the Hitda Gospels. And the early medieval crisis of word and image would have been especially apparent in Cologne, where the manuscript was made. Essen, with its idol-like Madonna and its biblically sanctioned seven-branched candlestick, was not far distant. Even closer was Cologne's cathedral, with its three-dimensional Christ on the cross donated by Gero, a relative of Hitda. In this fraught environment in 1000 there was an acute need for a solution to the crisis of word and image that had plagued the early Middle Ages since Gregory's influential but insufficient letter. Images demanded a more complex theology and a more complete description of their function than Gregory had provided in his brief pastoral remarks to a Mediterranean bishop. The verses in the Hitda Gospels are one radical attempt at a solution; another, equally radical solution is described in the Conclusion.

5

Inscriptions and Images

Artist and Patron in the Early Middle Ages

 ot one artist appears by his proper name in the preced-
ing pages. And on only one occasion did I identify an
artist with his modern, made-up name (the Master of
the *Registrum Gregorii*). This suppression of artists'
names, both given and invented, is partly my preference; more could
have been used. For example, [42] and [43] were painted by someone
named Liuthard. But we know so little about this Liuthard that it
seemed unimportant to mention his name, for it tells us next to noth-
ing. Even less informative, of course, are the modern sobriquets made
up by art historians to fill the gaps in the historical record. These,
typically, are banal ([34], [36]–[38], and [62], among the greatest glo-
ries of medieval painting, are ascribed to "Master C of the Vivian
Bible"), telling us more about modern art historians than about early
medieval artists.

Our lack of knowledge about individual early medieval artists stems
only in small part from the tremendous loss of historical information
from the period. That loss is real, but it is far from total. After all, al-
though this book lacks the names of artists, it is filled with the given
names of patrons: Charlemagne, Benedict Biscop, Charles the Bald,
Alfred the Great, Otto III, Hitda, Gero, and others have all figured
prominently. It is true that information about these people was more

extensive because of their social prominence (more was written about them and so more survives). But that does not explain much, since the evidence for early medieval artistic patronage typically comes not from the medieval historian's usual sources, documents or narratives, but from inscriptions on the works of art themselves, inscriptions executed by the very artists whose names do not survive. This chapter examines what written and pictorial evidence can tell us about early medieval artists and patrons.

My de-emphasis of individual artists reflects the period's attitude toward them; artists were unimportant in the early Middle Ages.[1] An apparent exception to that general statement is revealing. In the first half of the ninth century, Angilbert, the bishop of Milan, donated a sumptuous golden altar to the church of St. Ambrose in his episcopal city. All four sides of the altar are decorated with scenes from the lives of Christ and Ambrose. At the back, on either side of the doors giving access to the saint's relics, are two roundels. In one, Ambrose places a crown on the head of Angilbert, who is represented holding the altar he ordered made for the saint [59]. The figures are identified by inscriptions and attributes; Angilbert has the special square halo sometimes used to denote living persons of exceptionally high rank. Such donor portraits are typical of early medieval art. More unusual is the other roundel [60]. Ambrose is again crowning a man, this time one without a halo. An inscription tells us that he is "Master Wolvinus, craftsman." Nothing else is known of Wolvinus, although the name suggests he came from north of the Alps.

Some, not believing that a medieval artist could be shown in such a lofty position so close to a saint, have suggested that Wolvinus must have been the (hypothetical) designer of the altar's iconographic program rather than the man who actually made the altar. But Wolvinus is called *"faber"* (craftsman or smith), a term that almost unambiguously refers to a maker rather than a thinker. We, who regard artists as intellectuals, may find this line between makers and thinkers arbitrary and inappropriate, but it was this distinction that determined the low social status of artists, not only in the early Middle Ages but well into the modern era. According to ancient and medieval schemes for classifying knowledge, visual art was not placed with the liberal arts, those practiced by free men using their minds ("liberal" is a cognate here of

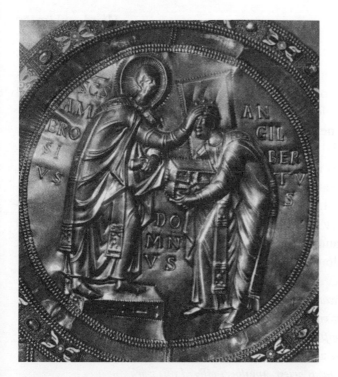

59
St. Ambrose crowns the patron
Angilbert. From the Milan
altar. Italy (?), 824–859.
Milan, Sant'Ambrogio. Photo:
Centrum Kunsthistorische
Documentatie, Katholieke
Universiteit Nijmegen

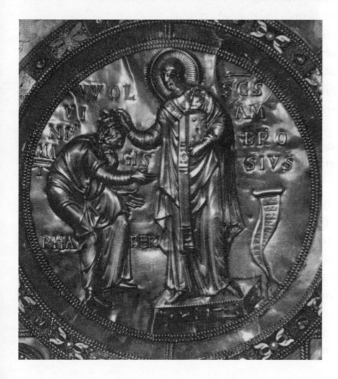

60
St. Ambrose crowns the
artist Wolvinus. From the
Milan altar. Italy (?),
824 859. Milan,
Sant'Ambrogio. Photo:
Centrum Kunsthistorische
Documentatie, Katholieke
Universiteit Nijmegen

"liberty"); rather, it was a mechanical art, performed by slaves or laborers who used their hands. Only in the nineteenth century did this distinction break down more or less completely, allowing the visual arts to achieve the elevated intellectual status they have today.

The image on the Milan altar lifts Wolvinus out of the anonymity and marginal social position that were characteristic for early medieval artists. Does it elevate him to something like a modern artist, an independent creator, an intellectual force blessed with special powers? I believe not, for Wolvinus, unlike a modern artist, is still perceived as subsidiary to a patron. Angilbert's prominence is indicated both by his halo and by the long dedicatory inscription in verse that runs around the altar:

> *This dear, beautiful ark gleams on the outside with a shining*
> *decoration of metals; ornamented, it shines with gems.*
> *Inside, this gift is rich with sacred bones,*
> *shining more with that treasure than with decorated metal.*
> *The good, famous priest Angilbert offered this work*
> *in honor of the blessed Ambrose who rests in*
> *this temple. He anxiously dedicated it to God,*
> *through whom, in time, he will dwell in the peaks of the*
> *shining seat.*
> *Seek, highest father, to have mercy on your son;*
> *with your mercy, God, he will carry off the sublime gift.*[2]

I discuss this fine statement of the motives of medieval patrons below. What is important in the present context is the complete absence from the poem of any mention of Wolvinus or any other artist. Angilbert is actively described as a patron, but to judge from these verses, the altar somehow made itself. This eclipse of the artist is not unique to the Milan altar; works of medieval art were often inscribed "*X* made me," in which *X* is the name not of the artist but of the patron. Wolvinus got his picture on the Milan altar but he could not get his name into the inscription, and, as we have seen, words were valued more highly than images by the Carolingians.

The low social and intellectual status of artists in the early Middle Ages does not mean they did nothing. Much of this book has been a

critical commentary on Gregory's attempt to reduce pictures to ersatz books. Pictures work in all kinds of nontextual ways that must have been at least partially the preserve of artists (or, to use what is perhaps a less loaded word, craftsmen). The frontispiece to Leviticus of the San Paolo Bible [45], to take just one example, is the product of a truly exceptional pictorial intelligence. Even if we give all of the intellectual credit for the complex iconographic programs I have described to the patrons, someone still had to make crucial decisions about where to put the figures and how to arrange them for expressive purposes. Such decisions can hardly have been the province of patrons. And of course, patrons would not have had the exquisite technical skills needed to make the objects in this book.

I believe it is impossible to talk about almost any individual early medieval artist in a historically responsible way; our base of evidence is simply too small. For the same reason, it is also difficult to make generalizations. But a few facts, chosen almost at random, give some idea of the range of social positions occupied by early medieval artists. For example, the laws of the Germanic tribes who entered the late Roman Empire and formed one of the bases of early medieval civilization valued goldsmiths highly. The fine for killing an ordinary person was thirty *solidi* (a *solidus* was the basic Roman coin), and for a blacksmith it was fifty *solidi*; it rose to one hundred *solidi* in the case of a silversmith and to two hundred for a goldsmith.[3] Although these fines suggest a highly elevated social standing for early medieval goldsmiths (and recall the depiction of Weland the Smith on the Franks Casket [15]), it is important to note that the fines were to be paid to the owners of the murdered men. Smiths were slaves, particularly valuable possessions whose loss demanded special recompense. These were not artists in the modern sense, even if their skills elevated them above some other men.

Not all early medieval art was made by free men; nor was all of it made by monks, as is commonly believed. Although monastic craftsmen were more prevalent in the early Middle Ages than later, when lay professionalism came to dominate most occupations including art making, an interesting piece of visual evidence tells us that the laity was involved even early on. A miniature from a manuscript made about 1040 at Echternach in present-day Luxembourg shows the

monastic scriptorium with two men at work [61]. One is clearly identified as a monk by his hooded robe and his tonsure; the other's dress just as clearly marks him as a layman. Both men seem to be pursuing the same activity, apparently writing the book, so we should resist the temptation to identify the layman as the artist and the monk as the scribe, a temptation that arises because painting did not require literacy and so would have been the more likely lay profession. Whatever their precise tasks, this image makes it clear that laymen and monks worked together. This was probably especially the case for the luxury objects that are the subject of this book, works that demanded special skills and perfect control of craft. Such commissions were probably farmed out to the most skilled workers available, monastic or lay.

Medieval artists worked under conditions very different from those of modern artists. What about patrons? Why did Charles the Bald or Egbert commission works of art? Motives surely varied, but some patterns are apparent from the verbal evidence of the inscriptions on the objects themselves. The poem from the Milan altar tells us that Angilbert donated the altar in the express hope that Ambrose and God would look favorably on the gift and reward him with eternal life. Such frank language, requesting something in return for the gift, is absolutely typical; this was the primary reason for artistic patronage in the early Middle Ages. Also typical is the poem's emphasis not on the intellectual content of the images but on their raw material value. Art here is a substitute for money rather than a source of transcendent aesthetic experience, as it is for us.

Art might also be given not in the hope of future rewards but as thanks for past intervention by the divine. The inscription on the altar frontal of Henry II [25] calls St. Benedict a doctor, a reference to an attack of kidney stones from which Henry was cured after praying to the saint. The object records Henry's thanks and simultaneously advertises that he had received Benedict's favor. Henry seems to minimize his importance by having himself depicted by a figure so small as to be barely visible, but the inscription names him, making his humility ostentatious. This apparent paradox, exaltation through humility, was a basic medieval pattern of thought. It had its roots in Christ's willingness to humiliate himself by becoming human, the event that allowed his exalted role as mankind's savior.[4] Exalted hu-

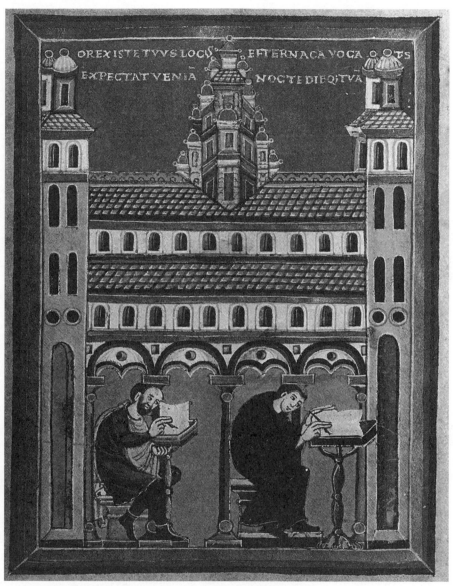

61 *Layman and monk at work on manuscript. Pericopes of Henry III. Echternach,*
1039–1043. Bremen, Universitätsbibliothek, msb 0021, fol. 124v. Photo:
Rheinisches Bildarchiv, Köln

mility lay behind much early medieval artistic patronage. For example, Theodulf, in the titulus to the Germigny-des-Prés apse mosaic [47], asked those who looked at the mosaic "to move the Thunderer [God] with your prayers and include Theodulf in your supplications."[5] Rather than demanding divine favor directly, as Angilbert had done, Theodulf presents himself as humble; he needs us to pray for him. Yet it is Theodulf who will be included in our prayers, for his name appears in silver letters below the sumptuous golden mosaic; his humility is of a different order than the humility of those who pray on his behalf.

One of the best statements of the motives of early medieval patrons and of the mechanics of patronage appears in a gospel book from Tours made around the middle of the ninth century for Charles the Bald's brother, Emperor Lothar I. The book's first page contains an image of Lothar on an ornate throne, flanked by two guards [62]. The ruler points with his left hand to the facing page, which bears a poem written in gold ink:

> For pious Augustus himself, led by the love of Christ,
> saw that there might be this most propitious ornament for the
> church;
> out of veneration for the blessed priest Martin
> he ordered the flock [the monks of St. Martin] to write the
> inside of this book beautifully
> and decorate it reverently with his gold and with pictures,
> so that it might be known how much influence this place has.
> Obedient Sigilaus, studiously following the orders of the king,
> commanded that they write this entire gospel book
> because he wanted Caesar to be the brother of the
> aforementioned flock,
> so that humble [Lothar] might seize the heavenly gift.
> Needless to say, the flock prays to the Almighty with all its effort
> for Augustus's strength and eternal prosperity
> and for his venerable wife and offspring.
> The king is depicted on this page
> so that whoever might some time see here the face of Augustus
> suppliant will say, "praise to all-powerful God.

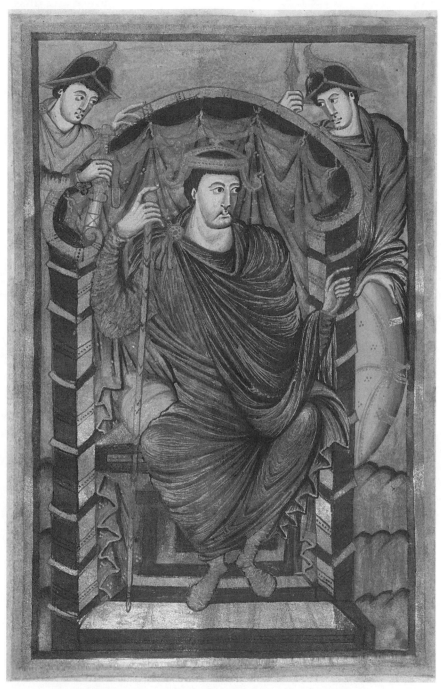

62 *Lothar enthroned. Lothar Gospels. Tours, c. 850. Paris, Bibliothèque nationale,*
ms. lat. 266, fol. 1v. Photo: Cliché Bibliothèque nationale de France, Paris

Lothar deserves to have perennial rest
through our Lord Jesus Christ, who reigns everywhere."[6]

Although we cannot accept these verses at face value as an account of how a luxury manuscript was made in the early Middle Ages, the poem is a precious testimony to the early medieval ideology of patronage. It begins by telling us that Lothar, recognizing the importance of St. Martin's monastery at Tours, wanted to give the monks additional honor through his gift of a gospel book. The Lothar Gospels, like the other luxurious objects discussed in this book, were so prestigious that they would have given honor even to a wealthy monastery such as Tours; their possession would demonstrate to others the owner's importance.

The monks were interested in receiving Lothar's patronage; the emperor, for his part, wanted to curry their favor. Tours was one of the most important Carolingian monasteries, controlling great amounts of spiritual and material capital. The Lothar Gospels were made soon after the end of the civil war between Lothar and his brothers in 843. The war resulted in the partition of the Carolingian empire: Tours lay in Charles the Bald's kingdom, and Lothar ruled further to the east, in the area of the present-day French-German border. Given this fraught situation, Lothar's decision to order the manuscript from Tours surely had political implications, although no scholar has yet fully explored them.

After explaining briefly Lothar's motives as a patron, the poem proceeds to the mechanics of production, telling us that Lothar commanded the monks to write the book beautifully and to decorate it with gold and with pictures. Like some other early medieval luxury manuscripts, the Lothar Gospels are written in gold ink. The verses specify that this is Lothar's gold. Apparently even an active and prolific scriptorium such as Tours required special materials, which were provided by the patron, to produce a manuscript of this richness. After Lothar had provided the impetus and the money, a Tours monk named Sigilaus (of whom little else is known) took charge of seeing the production through the monastery.

The poem now adds another motive, this one attributed to Sigilaus: Lothar's patronage of the manuscript will make the emperor a

brother to the monks at Tours, that is, a monk himself. This is not to be taken entirely literally. There is no desire for Lothar physically to join the monastic community at Tours; rather, he will become a sort of honorary brother, a common relationship between rulers and monks in the early Middle Ages.7 One part of the bargain the monks are striking here with Lothar includes their agreement to pray for his soul and for those of his wife and children. There is no reason not to take this part of the dedicatory poem seriously. There may have been political motives underlying Lothar's command to make this manuscript, but there were surely pious ones as well. Indeed, the separation of political and pious, church and state, priest and king is impossible in the early Middle Ages. Only much later do these concepts become the opposites they are for us.

The final lines of the dedicatory poem are among the most important for the art historian. To this point the verses have provided valuable evidence about the motives of patron and maker and the mechanics of the manuscript's production. Now images play a role. Lothar

> *is depicted on this page*
> *so that whoever might some time see here the face of Augustus*
> *suppliant will say, "praise to all-powerful God."*

The picture is meant to function as a mnemonic device, summing up and recalling for us the monks' desire that we, the viewers of this miniature, pray for Lothar. The image is a spur to devotion, and it reminds the viewer why the manuscript was made, functions far removed indeed from Gregory's conception of pictures as the books of the illiterate. Once again, Gregory's simple theory of images as substitutes for words proves insufficient to account for the richness and diversity of early medieval image practice. What is perhaps the crowning example of that insufficiency is discussed in the Conclusion.

Conclusion

"Brother, What Do You Think of This Idol?"

he reliquary statue of St. Faith (Latin *Fides*; French *Foy*) is still preserved in the southwestern French abbey church at Conques for which it was made, probably at the end of the ninth century or in the first part of the tenth ([Plate IV, [63]). This work is exemplary of early medieval art, both retrospective and prospective, but it is also unique.

In the late ninth century the Conques monks stole Faith's relics from the nearby town of Agen. Although such thefts may seem incredible for their impiety, they were common in the Middle Ages; they even had their own name: *furtum sacrum*, holy robbery. Conques needed a prestigious relic to rival successfully the neighboring monastery at Figeac. Relics were valuable and expensive commodities; without a good way to obtain them legitimately, the monks from Conques stole Agen's. Such thefts were typically self-fulfilling prophecies; if successful, it was claimed that the saint must have wanted the relics to be stolen or else she would not have allowed the theft.[1]

We may not approve of the theft, but we can hardly help approving what the Conques monks did with their relics. The statue of St. Faith is a remarkable object. The head is not early medieval at all; rather, it is a late antique ceremonial helmet, probably depicting the Roman emperor, into which have been set distinctive staring enameled eyes. The rest of the statue is an amalgam of gold and jewels, many of them gifts to the saint from pilgrims and other visitors to the abbey. Faced

63
Reliquary statue of St.
Faith (side view of head).
Conques, late ninth–first
half of tenth century.
Conques Abbey, Treasury.
Photo: Centrum
Kunsthistorische
Documentatie, Katholieke
Universiteit Nijmegen

with this object, the modern conception of the artist becomes almost meaningless. The statue did not have a single creator. Instead, it was a work in progress throughout the Middle Ages, assembled from disparate elements as pilgrims continued to make donations to the saint, which were added to the reliquary. Damaged or outmoded parts were continuously reworked to keep the statue functioning; the present hands and feet, for example, date only from the very end of the Middle Ages or even the Renaissance.

In the early eleventh century a young cleric named Bernard of Angers wrote a book-length account of Faith's miracles, a succession of stories about how the saint defended pilgrims to her shrine and attacked the monks' enemies. Pilgrimage was a crucial source of income for the monks, and Faith was particularly aggressive in soliciting gifts; as this typical miracle shows, "Sainte Foy Was No Snow White":[2]

Once in a famine, the revered image in which the holy martyr's head is preserved was carried out-of-doors in a huge procession. It happened by chance that a man coming toward the procession passed by very near to

the statue. When he saw the effigy radiant with glowing reddish gold and blazing gems, he was blinded by a cloud of greed and said, "Oh, if only that image would slip from the shoulders of the bearers and fall to the ground! No one would gather up a greater portion of the shattered stone and broken gold than I."

While the foolish man was muttering these words, the mule on which he was sitting bent its head down between its front legs and kicked up its hind legs so that they flew over the rider's head. The man ended up in the mud under the heavy hindquarters of the mule.[3]

The image is no longer Gregory's substitute text; it is now a spectacular vessel for the powerful but visually unimpressive relic hidden inside. Not surprisingly, this shift in the conception of the image made some people nervous. One of them was Bernard. He recognized the power of Faith's statue and was concerned by it. Indeed, so worried was Bernard that he stopped his account of Faith's miracles to describe and justify her image:

There is an established usage [in southern France] that people erect a statue for their own saint, of gold or silver or some other metal, in which the head of the saint or a rather important part of the body is reverently preserved. To learned people this may seem to be full of superstition, if not unlawful, for it seems as if the rites of the gods of ancient cultures, or rather the rites of demons, are being observed. [Upon seeing such a statue of a saint] I burst forth in Latin with this opinion:

"Brother, what do you think of this idol? Would Jupiter or Mars consider himself unworthy of such a statue?" (77)

Bernard was a cleric, educated at the cathedral school of Chartres, one of the leading centers of learning in his era. Chartres lies north of the Loire River, the traditional dividing line between northern and southern France; Conques lies far to the south. Bernard began his text by establishing for his northern audience that images like that at Conques are not universal but particular to southern France, that is, foreign (recall that the statue reliquary of Baudimus was also southern French; [56]). Bernard also took care to note that he spoke to his companion in Latin. The boundary drawn here is not geographical

but social. By this time in northern France, Latin was a learned language rather than a mother tongue, so the educated cleric Bernard is distinguishing himself from the unlettered speakers of the vernacular (in this case a form of Provençal).

After having established his distance from the events he is describing and having condemned them, Bernard presented his conception of the proper Christian attitude toward images:

> Where the cult of the only high and true God must be practiced correctly it seems an impious crime and an absurdity that a plaster or wooden and bronze statue is made, unless it is the crucifix of Our Lord. The holy and universal church accepts this image, in either carved or modeled form, because it arouses our affective piety in the commemoration of Our Lord's Passion. But the saints ought to be commemorated by displaying for our sight only truthful writing in a book or insubstantial images depicted on painted walls. For we allow the statues of saints for no reason other than very old, incorrect practice and the ineradicable and innate custom of simple people. (77–78)

Bernard permits images of Christ because they bring about "affective piety" in the viewer; they help the viewer to relive Christ's suffering. Although this justification of images is different from Gregory's argument that images are books for the illiterate, it was quite common in the early Middle Ages.[4] Much more unusual is the distinction Bernard draws between the permitted three-dimensional images of the crucified Christ and representations of other Christian figures, which can only be either written or "insubstantial images depicted on painted walls." Two-dimensional images were apparently less susceptible to the charge of idolatry than sculptures in the round. This argument would have permitted the Gero Cross ([57]), but forbidden the Essen Madonna ([49]), the Baudimus reliquary, and of course, the statue-reliquary of Faith.

When Bernard finally reached Conques, the image of Faith began to work on him, despite his predilection against such statues:

> After the third day we finally arrived at Conques. When we had entered the monastery, fate brought it about, quite by chance, that the separate

place where the image is preserved had been opened up. We stood nearby, but because of the multitude of people on the ground at her feet we were in such a constricted space that we were not even able to move forward. And, with a sidelong smile I looked back at Bernier, my scholarly companion, thinking it absurd, of course, and far beyond the limits of reason that so many rational beings should kneel before a mute and insensate thing. In truth my empty talk and smallmindedness at this time did not arise from a good heart. For the holy image is consulted not as an idol that requires sacrifices, but because it commemorates a martyr. Since reverence to her honors God on high, it was despicable of me to compare her statue to statues of Venus or Diana. Afterwards I was very sorry that I had acted so foolishly toward God's saint. (78)

Bernard's actual conversion to the statue's cause was accomplished by a miracle performed by the saint's image. Characteristically for the cult of St. Faith, this miracle is an economically charged one:

One day when the sacred image had been carried to another place for some necessary reason, a certain cleric named Odalric, who was considered a prig and held himself somewhat above the others, so subverted the people's hearts that he completely dissuaded the crowd from making offerings. He was greatly dishonoring the holy martyr and spreading some silly foolishness or other about her image. On the following night, when he had given his drunken body over to quiet rest, he had a dream in which a lady of terrifying authority seemed to stand before him.

"And you, worst of criminals," she said, "why have you dared to disparage my image?" After she said this, she applied the rod that she seemed to carry in her right hand and she left behind a beaten enemy. He only survived long enough afterward to be able to tell the story the next day. (78–79)

The saint, or her statue, kills a doubter. Bernard is sufficiently impressed that he becomes a devotee of Faith's statue, but now he needs to defend the image that he had formerly attacked. He offers a justification for images, or rather a whole series of them, not entirely consistent. Bernard touches all of the buttons of the early medieval image debate, but he touches them all at once, garbling the message.

Bernard was trained as a cleric, but he was no professional theologian, and his text shows some misunderstanding of the complex and sometimes contradictory Christian debate on images:

> After that [miracle] no room was left for argument as to whether the shaped image of Sainte Foy ought to be held worthy of veneration, because it was manifestly clear that he who criticized the statue was punished as if he had shown disrespect for the holy martyr herself. Nor did any doubt linger as to whether the image was a foul idol where an abominable rite of sacrifice or of consulting oracles was practiced. The image represents the pious memory of the holy virgin before which, quite properly and with abundant remorse, the faithful implore her intercession for their sins. Or, the statue is to be understood most intelligently in this way: it is a repository of holy relics, fashioned into a specific form only because the artist wished it. It has long been distinguished by a more precious treasure than the ark of the Covenant once held, since it encloses the completely intact head of a great martyr, who is without doubt one of the outstanding pearls of the heavenly Jerusalem. Therefore Sainte Foy's image ought not to be destroyed or criticized, for it seems that no one lapses into pagan errors because of it, nor does it seem that the powers of the saints are lessened by it, nor indeed does it seem that any aspect of religion suffers because of it. (79)

This is a remarkable passage. In trying to explain his change of mind about the idolatrous character of the image of St. Faith, Bernard is first convinced by a brute display of force: The saint beats Odalric to death after he attempts to deprive her (and especially her image) of wealth. From this Bernard draws the conclusion that disrespect for the statue is disrespect for the saint. Bernard thus erases the line between the representation and the thing it represents, and voices the most radical pro-image position possible, one associated not with the early medieval West (we have seen no other examples of it in this book) but with the extreme iconodule position in Byzantium. Bernard here sounds like the fourth-century Eastern church father Basil the Great, who claimed that "the honour paid to the image passes on to the prototype."[5]

This strong but simple statement, couched in the language of classical philosophy, was the most famous of all statements in defense of icons. It was deeply influential in Byzantium, but much less so in the West, which did not generally have access to the Neoplatonic philosophical tradition from which Basil drew. Drawing the line between image and prototype can be tricky, and if the relationship between the two is seen as particularly close, there is an almost unavoidable temptation to worship the sign rather than what it signifies (or to put it into Christian terms, "to worship and serve the creature rather than the Creator"; Rom. 1:25). This is idolatry. Bernard argued that the special attention paid to the reliquary of St. Faith was not idolatrous because the faithful used the statue only to remind them of the saint whose intercession they seek. The statue is the vehicle to the saint, not the saint herself.

This argument is theologically immaculate, but it is undercut by Bernard's insistence in telling miracle stories about the image rather than about the saint. Perhaps aware of this problem, Bernard gives other, very different arguments to justify the statue reliquary. He tries to explain it away, saying that the Conques statue is "understood most intelligently" as a reliquary that on the whim of the artist happens to be in the shape of a woman. Since the intellectual and social status of the medieval artist was not high, this explanation turns the statue into nothing: It is not an idol, with all an idol's power, but simply an oddly shaped reliquary. At this point Bernard sounds very much like such Carolingian arch-rationalists as Theodulf.

But faced with the raw power of the Conques image, Bernard knew that it really would not do to say it was nothing. He therefore complicated his argument, writing in a rich passage that the relic inside the statue, Faith's head, was a greater treasure than that once held in the Ark of the Covenant. Bernard starts with a familiar claim: The New Testament is so superior to the Old that the head of a Christian saint is worth more than tablets written by the hand of God himself. By mentioning the Ark, Bernard refers to the traditional justification of images that counters the Second Commandment by invoking the divinely sanctioned, image-bearing Ark. The Ark is particularly relevant here, since the cherubim on it, like the statue of St. Faith, were made of beaten gold. By referring specifically to the Ark's contents,

the tablets of the Law, Bernard also stakes out a position in the old word/image debate. For Bernard, a visible, material object, Faith's head (and by extension, the visible reliquary that elaborates on that head), trumps the words on the tablets, a radical inversion of the traditional early medieval emphasis on the word over the image.

This inversion was possible because Bernard understood the New Testament as the testament of vision and direct experience; he claims that Faith is "without doubt one of the outstanding pearls of the heavenly Jerusalem." It is no coincidence that the statue reliquary of the saint is studded with pearls. According to Bernard, by looking on these visual cues any viewer can gain direct knowledge of the Christian saint. This is in contrast to the words of the Old Testament Law, hidden out of sight in the Ark and in need of interpretation.

Despite his worries about idolatry, it is this last argument that proves the strongest; in the end Bernard, the highly literate cleric, cannot resist the power and attraction of the visual. In the letter he wrote dedicating his book, Bernard explained that as a student at Chartres he had already become interested in Faith (there was a chapel dedicated to her outside the town) and vowed to visit Conques, the site of her relics and miracles. He had heard about these miracles, although he was skeptical: "Partly because it seemed to be the common people who promulgated these miracles and partly because they were regarded as new and unusual, we put no faith in them and rejected them as so much worthless fiction" (39). Bernard's skepticism derived from class bias (Faith's cult was being promoted by "common people") and conservatism (her miracles were "new and unusual"). In other words, his reason outweighed the evidence of Faith's miracles, evidence that reached him through the ears (the stories Bernard heard must have been transmitted orally, since before he wrote his text there was no written account of Faith's cult).

Things changed when Bernard traveled to Conques:

Since the time of my arrival here I have begun to inquire diligently about Sainte Foy's miracles. Such a great number of miracles have poured forth from various narrators that if my mind had not been burningly eager to hear them my brain would have been overwhelmed with weariness. But I myself have been fortunate enough to see the very man

whose eyes were violently plucked out by the roots and afterward restored to their natural state, intact and whole. And I can see him even as I write this. Since he himself asserts that this really happened and the whole province attests to it, I know that it is true. Therefore I think that his story ought to be introduced first as the basis for reading the rest of the miracles, and not just my interpretation of his meaning, but word for word as I hear it from his lips; not abbreviated, but in a narrative long enough to satisfy my readers. (40)

Bernard's ambivalent attitude toward the visual in this passage is a microcosm of his ambivalence regarding the cult statue. We might imagine that when Bernard began his inquiries at Conques his eyes would be his most valuable tools, since he is on-site, an eyewitness. But his initial evidence is explicitly aural: Miracle stories pour forth from narrators. The words prove too voluminous and threaten to overwhelm Bernard with weariness until he sees a man who had been cured of blindness by St. Faith. Bernard considers this miracle involving vision so important that he opens his book with it, even though it was not the first of Faith's miracles. He is certain about the importance of this healing of the man's eyes because he can see the healed man as he writes his account. But he is also certain because the man told him and the whole province concurs, both verbal means of communication. Bernard emphasizes this verbal aspect by telling us that he will transcribe this miracle account "word for word" to satisfy his readers. The literate cleric Bernard is awed by the statue of St. Faith and his sight of the blind man cured by the saint, but his only recourse is to his medium, words, spoken and written. We thus end somewhere close to where we began; in the Middle Ages, as now, the visual has power, but for the literate that power is harnessed to words.

In his inability to escape the linkage of word and image, Bernard's account of the statue of St. Faith is characteristically early medieval. In other ways, however, the Conques reliquary statue points forward to later developments and thus distinguishes the art and society of the early Middle Ages from what followed. It is significant, for example, that the statue was made in southern France. This area was not an important center of early medieval artistic production because most art

then was made for a limited group of aristocratic patrons who were
centered around the royal and imperial courts of England, northern
France, and Germany. It is striking that not only were a relatively
small number of patrons responsible for most of the images discussed
in this book, but there were often personal or dynastic connections
between them. Charlemagne was the grandfather of Lothar I and
Charles the Bald; Charles the Bald was related to Alfred the Great by
marriage; Hitda and Gero may have been cousins. Indeed, one histo-
rian has persuasively argued that the prevalence of powerful statues
like that of St. Faith in Conques was a development of precisely the
period when the great early medieval dynastic systems were breaking
down: "It's no coincidence that these statues flourished in a period of
relative political fragmentation, where bishops, monasteries, and no-
bles represented different spheres of often competing power. The
reliquaries they patronized emanated the authority they craved."[6]

The increasing prominence of the pilgrimage to Compostela in
northern Spain (Conques was an important stop on the pilgrimage
route) and the great population increase of the twelfth century in Eu-
rope meant that formerly peripheral areas such as southern France
took on new importance. Another portent of future developments is
the monastic and popular, as opposed to royal, patronage of the
Conques statue. In the twelfth century, increasing monastic patron-
age, economically fueled by pilgrimage and by texts such as Bernard's,
significantly broadened the scope of artistic production and recep-
tion.

This diversity made any single concern more attenuated. As a re-
sult, the issue of word and image that was so focal to this book be-
came less central; it is not possible to look as successfully at Ro-
manesque art through the lens of word and image as it was to examine
the art of the early Middle Ages in that way. Yet in other ways West-
ern Europe in the eleventh century was a considerably more unified
place than it had been in 600. Catholic Christianity had spread every-
where, bringing with it doctrinal and linguistic conformity. This
unity meant that the often contentious relationship between word
and image apparent in this book was mitigated in the later Middle
Ages, making it less central to the understanding of later medieval art.

Notes

<center>❖⇒◎⇐❖</center>

Introduction

1. Cited in C. Chazelle, "Pictures, Books, and the Illiterate: Pope Gregory I's Letters to Serenus of Marseilles," *Word & Image* 6 (1990): 139 (translation slightly adapted).

2. For example, in the New Age fascination with things alleged to be Celtic or in Thomas Cahill's best-seller, *How the Irish Saved Civilization* (New York, 1995).

Chapter One

1. Bede, *History of the English Church and People*, I.25, trans. L. Sherley-Price (London, 1968), 69.

2. Cited in C. Chazelle, "Pictures, Books, and the Illiterate: Pope Gregory I's Letters to Serenus of Marseilles," *Word & Image* 6 (1990): 139 (translation slightly adapted).

3. Unless otherwise noted, all biblical citations in English are from the Douai-Reims Bible. Although not the most accurate rendering of the original Hebrew and Greek, this is the best version for studying the Western Middle Ages, since it translates the Vulgate, Saint Jerome's fourth-century Latin Bible in use throughout the period.

4. Gregory of Tours, *Glory of the Martyrs*, c. 21, trans. R. van Dam (Liverpool, 1988), 40.

5. Chazelle, "Pictures, Books, and the Illiterate," 139.

6. *The Letters of St. Boniface*, trans. E. Emerton (New York, 1940), 65.

7. The Gospel of Matthew is introduced by his symbol, the man, but this is a heavenly creature, not an earthly one.

8. Cited from G. Henderson, *From Durrow to Kells* (London, 1987), 195.

9. Bede, *History of the English Church and People*, I.30, 86–87.

10. J. Goody, "Literacy and the Non-literate: The Impact of European Schooling," in *The Interface Between the Written and the Oral* (Cambridge, 1987), 139–147 (quoted passage from 139); see also "The Impact of Islamic Writing on Oral Cultures," 125–138.

11. Bede, *History of the English Church and People*, I.1, 39–40. For the other examples cited in this paragraph, see J. Kelly, "Books, Learning, and Sanctity in Early Christian Ireland," *Thought* 54 (1979): 253–261; R. Ó Floinn, *Irish Shrines and Reliquaries of the Middle Ages* (Dublin, 1994), 36–37; and A. Lucas, "The Social Role of Relics and Reliquaries in Ancient Ireland," *Journal of the Royal Society of Antiquaries of Ireland* 116 (1986): 32.

12. J. Goody, "Restricted Literacy in Northern Ghana," in *Literacy in Traditional Societies*, ed. J. Goody (Cambridge, 1968), 198–264; the quotations that follow are from 230–231.

13. Cited from C. Davis-Weyer, *Early Medieval Art, 300–1150* (Toronto, 1986), 73–75.

14. Goody, "Restricted Literacy," 206.

15. This point was made by Erwin Panofsky in reference to the decline of manuscript illumination in the fifteenth century: "It has been said that book illumination was killed by the inven-

<center>149</center>

tion of printing; but it had already begun to commit suicide by converting itself into painting. Even without Gutenberg it would have died of an overdose of perspective"; *Early Netherlandish Painting: Its Origins and Character* (Cambridge, 1953), 28.

16. R. Page, *Runes* (Berkeley, 1987), 10.

17. "The fish beat up the seas on to the mountainous cliff; the king of terror became sad when he swam on the shingle: whalebone"; Page, *Runes*, 41.

Chapter Two

1. For a discussion of various theories of style and an interesting explanation of the problem, see E. Gombrich, *Art and Illusion: A Study in the Psychology of Pictorial Representation* (Princeton, 1961).

2. The paten for the Ardagh Chalice is lost, but a matching chalice and paten set from the Irish hoard recently discovered at Derrynaflan gives a good impression of what it must have looked like; M. Ryan, "The Derrynaflan Hoard and Early Irish Art," *Speculum* 72 (1997): 995–1018.

3. For the cross's back, see P. Lasko, *Ars Sacra, 800–1200*, 2nd ed. (New Haven, 1994), fig. 139.

4. Gregory of Tours, *Glory of the Martyrs*, c. 27, trans. R. van Dam, (Liverpool, 1988), 45–46.

5. For the influence of the Gregorian plan, as well as a discussion of other ways in which relics were displayed in early medieval churches, see W. Jacobsen, "Saints' Tombs in Frankish Church Architecture," *Speculum* 72 (1997): 1107–1143.

6. Einhard, *Life of Charlemagne*, c. 26, trans. P. Dutton, *Charlemagne's Courtier* (Peterborough, 1998), 32–33.

7. The postmedieval history of Aachen is treated in H. Belting, "Das Aachener Münster in 19. Jahrhundert: Zur ersten Krise des Denkmal-konzepts," *Wallraf-Richartz Jahrbuch* 45 (1984): 257–289.

Chapter Three

1. H. Kessler, "A Lay Abbot as Patron: Count Vivian and the First Bible of Charles the Bald," in *Committenti e produzione artistico-letteraria nell'alto medioevo occidentale*, Settimane di studio del Centro italiano di studi sull'alto medioevo 39 (Spoleto, 1992), 668–669.

2. Theologically, this iconography is defensible, since Christians believe that Christ, as *logos*, had existed from before creation. But the ivory carver's decision to specify Christ as the God who transferred the tablets to Moses is, as far as I know, unprecedented.

3. R. Walker, "Illustrations to the Priscillian Prologues in the Gospel Manuscripts of the Carolingian Ada School," *Art Bulletin* 30 (1948): 3.

4. For this crucial argument, see R. Krautheimer, "Introduction to an 'Iconography of Medieval Architecture,'" *Journal of the Warburg and Courtauld Institutes* 5 (1942): 1–33; reprinted in his *Studies in Early Christian, Medieval, and Renaissance Art* (New York, 1969), 115–148.

5. H. Kessler, *The Illustrated Bibles from Tours* (Princeton, 1977), 51–52.

6. The fascinating story of the shift and its implications is told in P. Brown, *The Cult of the Saints: Its Rise and Function in Latin Christianity* (Chicago, 1981).

7. J. Gaehde, "Carolingian Interpretation of an Early Christian Picture Cycle to the Octateuch in the Bible of San Paolo Fuori le Mura in Rome," *Frühmittelalterliche Studien* 8 (1974): 358–366; H. Kessler, "Through the Temple Veil: The Holy Image in Judaism and Christianity," in his *Studies in Pictorial Narrative* (London, 1994), 49–73.

Chapter Four

1. For a recent broad treatment, with references to further bibliography, see H. Belting, *Likeness and Presence: A History of the Image Before the Era of Art*, trans. E. Jephcott (Chicago, 1994).

2. *Opus Caroli regis contra synodum* (*Libri Carolini*), ed. A. Freeman, *Monumenta Germaniae Historica, Concilia* 2, supplementum I (Hanover, 1998); hereafter *MGH*. Unfortunately, the *LC* have never been well translated into English. A translation by A. Freeman is in progress; until it appears, for the English-speaking reader there are a few excerpts in C. Davis-Weyer, *Early Medieval Art, 300–1150* (Toronto, 1986), 100–103, and most of the text appears in a discontinuous translation in the notes to *The Seventh General Council, the Second of Nicea in which the worship of images was established: with copious notes from the "Caroline Books," compiled by order of Charlemagne for its confutation*, trans. J. Mendham (London, n.d. [c. 1850]).

3. A. Freeman, "Scripture and Images in the *Libri Carolini*," *Testo e immagine nell'alto medioevo*, Settimane di studio del Centro italiano di studi sull'alto medioevo 41 (Spoleto, 1994), 170–171.

4. *LC* I, c. 2; my translation.

5. *LC* II, c. 26; my translation.

6. D. Appleby, "Rudolf, Abbot Hrabanus, and the Ark of the Covenant Reliquary," *American Benedictine Review* 46 (1995): 419–443.

7. *Homilies on the Gospel of John* 24, 2, trans. J. Gibb and J. Innes, in *A Select Library of the Christian Church: Nicene and Post-Nicene Fathers*, first series, ed. Philip Schaff, vol. 7 (Buffalo, 1888), 158.

8. Trans. D. Ganz, "'Pando quod Ignoro': In Search of Carolingian Artistic Experience," in *Intellectual Life in the Middle Ages*, ed. L. Smith and B. Ward (London, 1992), 29.

9. Cited for the sake of familiarity from the King James Version, which deviates significantly from the Vulgate text in two places: in verse 2, the Vulgate waters are not still, although they refresh the psalmist; in verse 5 the psalmist's cup makes him drunk, but it doesn't overflow. Also, the psalm is twenty-two in the Vulgate numbering, not twenty-three.

10. "Defense and Reply to Abbot Theodemir," trans. A. Cabaniss, in *Early Medieval Theology*, ed. G. E. McCracken (Philadelphia, 1957), 242.

11. E. Bakka, "The Alfred Jewel and Sight," *The Antiquaries Journal* 46 (1966): 277–286.

12. Trans. J. Clarke and D. Hinton, *The Alfred and Minster Lovell Jewels* (Oxford, 1979), 8.

13. On medieval reading practices, see I. Illich, *In the Vineyard of the Text* (Chicago, 1993); and especially P. Saenger, "Silent Reading: Its Impact on Late Medieval Script and Society," *Viator* 13 (1982): 367–414; and idem, *Space Between Words: The Origins of Silent Reading* (Stanford, 1997).

14. *LC* III, c. 24; see D. Appleby, "Holy Relic and Holy Image: Saints' Relics in the Western Controversy over Images in the Eighth and Ninth Centuries," *Word & Image* 8 (1992): 333–343.

15. *The Martyrdom of Saint Polycarp, Bishop of Smyrna*, c. 18, trans. J. Kleist, Ancient Christian Writers 6 (New York, n.d.), 19.

16. *Acta sanctorum* January 2, 161; my translation.

17. I follow the dating in P. Lasko, *Ars Sacra 800–1200*, 2nd ed. (New Haven, 1994), 105. Other scholars date the Baudimus reliquary to the twelfth century, outside the chronological limits of this book. Even if they are right, as they may well be, written sources tell us that by the eleventh century there were many such statue reliquaries in southern France, although few survive from the earliest period.

18. Scholars debate whether Ibrahim was Muslim or Jewish. However, the positive reference to Jesus in the cited passage seems to indicate clearly that he was Muslim (Islam considers Jesus a prophet, but not the Messiah; Judaism is uninterested in Christ). But since Ibrahim's account survives only as part of later Muslim sources, the passage praising Christ could be an interpolation.

19. Ibrahim's full text has never been translated into English. My version is drawn from the German translation in P. Engels, "Der Reisebericht des Ibrahim ibn Ya'qūb (961/966)," in

Kaiserin Theophanu, ed. A. von Euw and P. Schreiner (Cologne, 1991), 1, 413–422, which I have checked against the French translation by A. Miquel, "L'Europe occidentale dans la relation arabe d'Ibrâhîm b. Ya'qûb (Xe. s.)," *Annales* 21 (1966): 1048–1064.

20. *Abbot Suger on the Abbey Church of St.-Denis and Its Art Treasures*, ed. E. Panofsky, 2nd ed. (Princeton, 1979), 49.

21. P. Bloch and H. Schnitzler, *Die ottonische Kölner Malerschule* (Düsseldorf, 1967), I, 46; my translation.

Chapter Five

1. For a different consideration of this entire issue, see the stimulating essay by L. Nees, "The Originality of Early Medieval Artists," in *Literacy, Politics, and Artistic Innovation in the Early Medieval West*, ed. C. Chazelle (Lanham, 1992), 77–109.

2. *MGH Poetae latini aevi carolini* 2, 665; my translation.

3. *The Burgundian Code*, trans. K. Drew (Philadelphia, 1976), 19–20 n. 4.

4. On exalted humility in early medieval art, see R. Deshman, "The Exalted Servant: The Ruler Theology of the Prayerbook of Charles the Bald," *Viator* 11 (1980): 385–417.

5. *MGH Scriptores* 15, 501; my translation.

6. *MGH Poetae* 2, 671; my translation.

7. J. Wollasch, "Kaiser und Könige als Brüder der Mönche: Zum Herrscherbild in liturgischen Handschriften des 9. bis 11. Jahrhunderts," *Deutsches Archiv für Erforschung des Mittelalters* 40 (1984): 1–20.

Conclusion

1. P. Geary, *Furta Sacra: Thefts of Relics in the Central Middle Ages* (Princeton, 1990).

2. The title of an article by K. Ashley and P. Sheingorn, *Journal of Ritual Studies* 6 (Winter 1991): 63–85.

3. *The Book of Sainte Foy*, trans. P. Sheingorn (Philadelphia, 1995), 79–80. All subsequent references to this book are given in the text.

4. The justification was also (wrongly) attributed to Gregory, based on a passage interpolated into one of the pope's letters; see D. Freedberg, *The Power of Images* (Chicago, 1989), 164, who mistakenly accepts the interpolated passage as authentic.

5. *On the Spirit* 18, 45, trans. B. Jackson, in *A Select Library of the Christian Church: Nicene and Post-Nicene Fathers*, second series, ed. P. Schaff and H. Wace (Buffalo, 1895) vol. 8, 28.

6. A. Remensnyder, "Un problème de cultures ou de culture?: La statue-reliquaire et les *joca* de Sainte Foy de Conques dans le *Liber miraculorum* de Bernard d'Angers," *Cahiers de civilisation médiévale* 33 (1990): 365; my translation.

Further Reading in English

⋆⋅≈⊙⊂⋆⋅

Alexander, J. *Medieval Illuminators and Their Methods of Work.* New Haven, 1992. Though not limited to early medieval art, this book is full of fascinating evidence about the production of medieval manuscripts.

The Art of Medieval Spain, A.D. 500–1200. New York, 1993. Catalogue of an exhibition organized by the Metropolitan Museum of Art, New York, but unfortunately never held. Spanish material plays only a small part in my book owing to lack of space, but the early medieval pictorial tradition there was rich, varied, and extremely interesting because of the interaction of Christianity and Islam.

Backhouse, J. *The Lindisfarne Gospels.* Oxford, 1981. This is a concise, affordable, and extremely well illustrated monograph on this important manuscript.

Backhouse, J., D. H. Turner, and L. Webster, eds. *The Golden Age of Anglo-Saxon Art, 966–1066.* London, 1984. This is a well-illustrated catalogue of a British Museum exhibition.

Barasch, M. *Icon: Studies in the History of an Idea.* New York, 1992. Although not dealing directly with the early medieval West, this book provides a useful introduction to classical, late antique, and Byzantine image theory.

Barral i Altet, X. *The Early Middle Ages from Late Antiquity to A.D. 1000.* Cologne, 1997. A volume in the well-illustrated Taschen's World Architecture series, this book has many color plates of what remains of early medieval architecture as well as a reliable text.

Belting, H. *Likeness and Presence: A History of the Image Before the Era of Art.* Translated by E. Jephcott. Chicago, 1994. In this broad-ranging study of the image in the Middle Ages, emphasizing the cult of icons and their use in Christian ritual, Belting argues (as the polemic subtitle indicates) that the medieval image was not art in the modern sense.

Brown, P. *The Cult of the Saints: Its Rise and Function in Latin Christianity.* Chicago, 1981. This remarkable study of the origin of the medieval cult of saints and relics indicates the continuities and especially the breaks with the classical tradition.

Calkins, R. *Illuminated Books of the Middle Ages.* Ithaca, 1983. The first five chapters of this book concern early medieval manuscripts. Particular attention is paid to the insular gospel books, the Vivian Bible, Charles the Bald's *Codex aureus,* and the Drogo Sacramentary.

Carver, M. *Sutton Hoo: Burial Ground of Kings?* Philadelphia, 1998. This accessible treatment of Sutton Hoo is written by the current excavator.

Conant, K. *Carolingian and Romanesque Architecture 800 to 1200.* Harmondsworth, England, 1966. Although somewhat outdated, this is nevertheless one of the few scholarly treatments of early medieval architecture in English.

Davis-Weyer, C., ed. *Early Medieval Art, 300–1150.* Toronto, 1986. The selections included here of early medieval texts about art are both interesting and useful.

Dodwell, C. *The Pictorial Arts of the West, 800–1200.* New Haven, 1993. In this well-illustrated introduction to medieval manuscript illumination and wall painting, the author's focus is almost entirely on the history of style.

Dutton, P., and H. Kessler. *The Poetry and Paintings of the First Bible of Charles the Bald.* Ann Arbor, Mich., 1997. This book painstakingly reconstructs the precise historical situation in which the Vivian Bible was made.

Fletcher, R. *The Barbarian Conversion from Paganism to Christianity.* New York, 1997. Fletcher presents a recent, general historical study of the period under consideration in my book.

Goody, J., ed. *Literacy in Traditional Societies.* Cambridge, England, 1968. Particularly important in this series of studies of the role of literacy in traditional societies (such as that of early medieval Europe) are the pathbreaking essay by Goody and I. Watt, "The Consequences of Literacy" (27–68) and Goody's "Restricted Literacy in Northern Ghana" (198–264).

Grabar, A., and C. Nordenfalk. *Early Medieval Painting from the Fourth to the Eleventh Century.* Lausanne, n.d. Nordenfalk's section has been reprinted as *Early Medieval Book Illumination.* New York, 1988. This sometimes detailed introduction to early medieval wall painting and manuscript illumination is useful and well illustrated.

Harper, J. *The Forms and Orders of Western Liturgy from the Tenth to the Eighteenth Century.* Oxford, 1991. This clear and complete guide to the Christian liturgy is more useful for nonspecialists than J. Jungmann's classic two-volume study, *The Mass of the Roman Rite.* New York, 1951.

Henderson, G. *From Durrow to Kells: The Insular Gospel-books 650–800.* London, 1987. The difficult problem of interpreting the Durrow, Lindisfarne, and Kells Gospels is given a thorough, intelligent treatment here.

———. *Vision and Image in Early Christian England.* Cambridge, England, 1999. Henderson presents an interesting cultural study of the art produced in England in the first two centuries after the conversion of the Anglo-Saxons to Christianity.

Hubert, J., J. Porcher, and W. Volbach. *The Carolingian Renaissance.* New York, 1970. Although a bit outdated, this is still the most solid and comprehensive English-language introduction to Carolingian art; it is profusely illustrated with both familiar and unfamiliar works of art.

———. *Europe of the Invasions.* New York, 1969. This companion volume to the authors' *The Carolingian Renaissance* covers a wide and interesting range of material from late antiquity to the Carolingian period. Densely illustrated.

Kitzinger, E. *Byzantine Art in the Making: Main Lines of Stylistic Development in Mediterranean Art, Third–Seventh Century.* Cambridge, Mass., 1980. This is an exceptionally subtle and sophisticated consideration of the significance of style in late antique and early medieval Mediterranean art.

Lasko, P. *Ars Sacra, 800–1200.* 2nd edition. New Haven, 1994. With primary emphases on style and technique, the author gives a solid, well-illustrated treatment of art used in the service of the Christian liturgy.

Markus, R. *Gregory the Great and His World.* Cambridge, England, 1997. This is an authoritative, recent account of Gregory and his context.

Mayr-Harting, H. *The Coming of Christianity to Anglo-Saxon England.* 3rd edition. University Park, Pa., 1991. The history of the conversion of England to Christianity is presented in a reliable, readable text.

———. *Ottonian Book Illumination: An Historical Study.* 2 vols. London, 1991. Written by a historian, this book emphasizes the historico-political context of Ottonian illuminated manuscripts; it is richly illustrated and one of the rare detailed treatments of the subject in English.

McKitterick, R., ed. *Carolingian Culture: Emulation and Innovation.* Cambridge, England, 1994. These useful essays on most facets of Carolingian culture are scholarly but accessible.

———. *The New Cambridge Medieval History.* Vol. 2: *C. 700–c. 900.* Cambridge, England, 1995. This essential text gives comprehensive, up-to-date scholarly essays on all aspects of early medieval history with thorough bibliographies.

Meehan, B. *The Book of Durrow.* Dublin, 1996. This is an inexpensive and widely available edition with color reproductions of all the decorated pages.

Mütherich, F., and J. Gaehde. *Carolingian Painting.* New York, 1976. This is a reliable introduction to the subject, with many color reproductions.

Nees, L., ed. *Approaches to Early-Medieval Art.* Cambridge, Mass., 1998. This series of seven essays and an editor's introduction first appeared in *Speculum* 72 (1997). Although the individual essays are quite narrowly focused, as a whole they provide a good introduction to many of the problems involved in the study of early medieval art.

Neuman de Vegvar, C. *The Northumbrian Renaissance: A Study in the Transmission of Style.* Selinsgrove, Pa., 1987. This discussion of art made in northern England in the seventh and eighth centuries is reliable and thorough.

Nordenfalk, C. *Celtic and Anglo-Saxon Painting.* New York, 1977. This is a generally reliable introduction with many color illustrations.

Ong, W. *Orality and Literacy: The Technologizing of the Word.* London, 1982. In this, the best single account of the effects of literacy on the human mind, chapters 3, "Some Psychodynamics of Orality," and 4, "Writing Restructures Consciousness," are particularly relevant.

Pächt, O. *Book Illumination in the Middle Ages: An Introduction.* London, 1986. Medieval book illumination is given an interesting, thematic treatment; particularly relevant is chapter 2, "The Initial."

Price, L. *The Plan of St. Gall in Brief.* Berkeley, 1982. This abridgment of W. Horn and E. Born's three-volume study of a remarkable, detailed plan of a Carolingian monastery is a good introduction both to early medieval building and to monasticism.

Richter, M. *The Formation of the Medieval West: Studies in the Oral Culture of the Barbarians.* New York, 1994. The evidence for early medieval oral culture is assembled and assessed.

Safran, L. ed. *Heaven on Earth: Art and the Church in Byzantium.* University Park, Pa., 1998. Although the essays in this collection on Byzantine art were written by leading specialists, they are intended for the general reader and form a good introduction to Byzantine art, an important subject treated only peripherally in my book.

Swarzenski, H. *Monuments of Romanesque Art.* Chicago, 1967. Despite the title, this book includes Carolingian, Ottonian, and Anglo-Saxon art; it is methodologically out of date but still valuable for the hundreds of photographs, including many details.

The Utrecht Psalter in Medieval Art: Picturing the Psalms of David. Edited by K. van der Horst, W. Noel, and W. Wüstefeld. London, 1996. This exhibition catalogue is a thorough introduction to early medieval Psalter illustration, both East and West, with special attention to Carolingian material.

Webster, L., and J. Backhouse, eds. *The Making of England: Anglo-Saxon Art and Culture,* AD 600–900. Toronto, 1991. This fine, well-illustrated catalogue of a British Museum exhibition also contains excellent introductory essays.

Wilson, D. *Anglo-Saxon Art from the Seventh Century to the Norman Conquest.* Woodstock, New York, 1984. This is a reliable, very well illustrated treatment.

Youngs, S., ed. *"The Work of Angels": Masterpieces of Celtic Metalwork, Sixth–Ninth Centuries AD.* London, 1989. This catalogue of an exhibition of Celtic metalwork contains both ecclesiastical and secular art.

Index